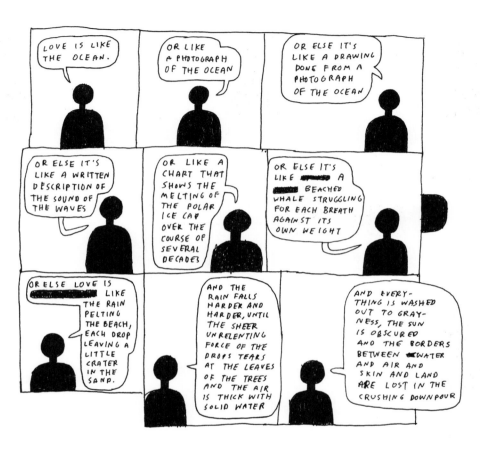

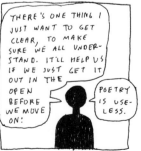

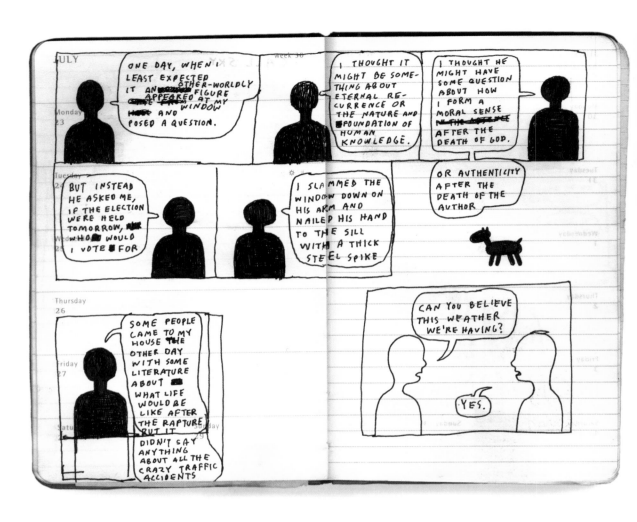

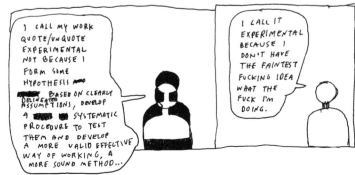

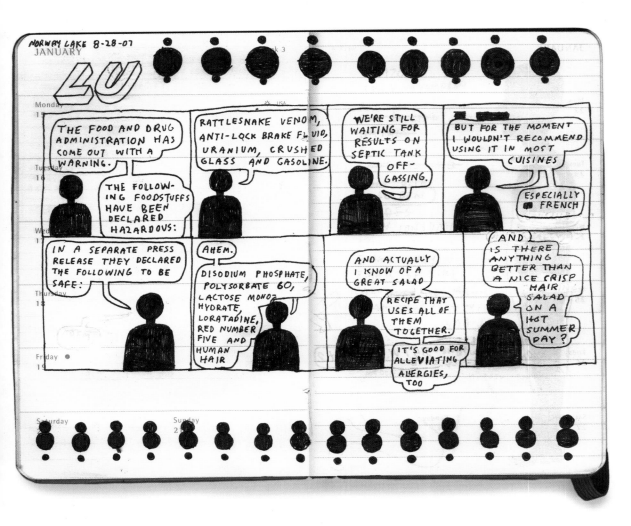

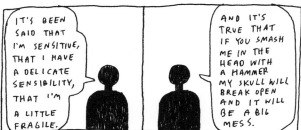

THE BENEFIT OF HAVING ALIENATED GOD, HAVING OFFENDED HIM, DRIVEN HIM AWAY SO THAT THE TWO OF YOU ARE NO LONGER SPEAKING IS THAT AT LEAST HE'S NOT TELLING YOU WHAT TO DO ALL THE TIME.

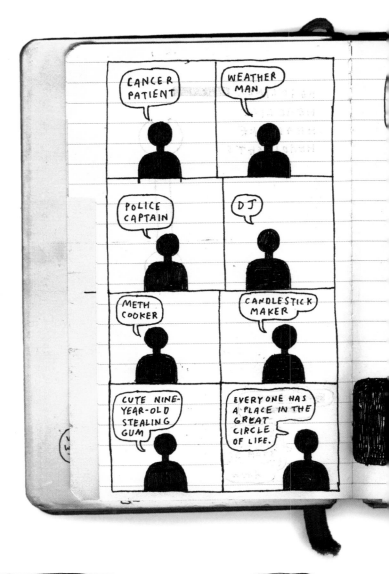

IT'S ALSO BEEN SAID, HOWEVER, THAT I AM NOT FLAMMABLE.

IN GENERAL THIS IS TRUE, EXCEPT FOR MY HAIR. MY HAIR BURNS READILY.

IN FACT, ONCE ALIGHT IT IS QUITE DIFFICULT TO GET IT PUT OUT AGAIN.

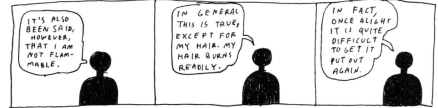

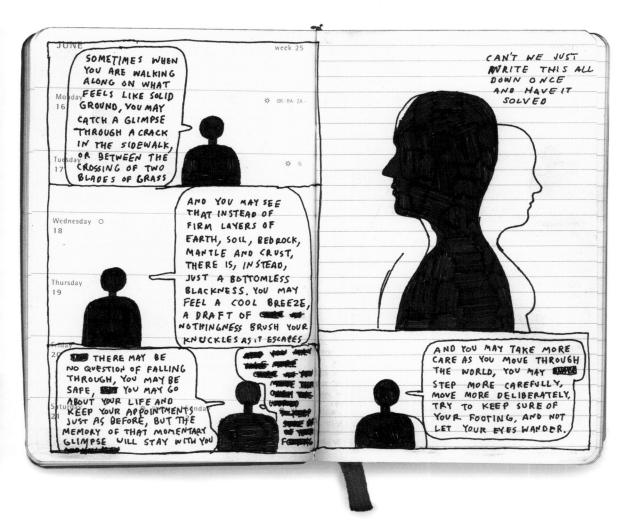

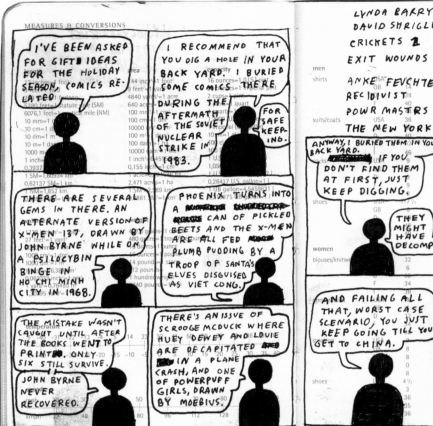
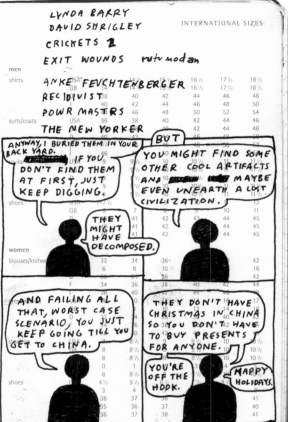

BILL KARTALOPOULOS

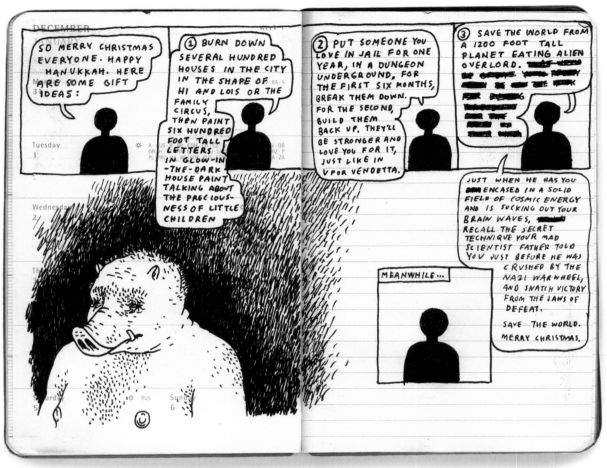

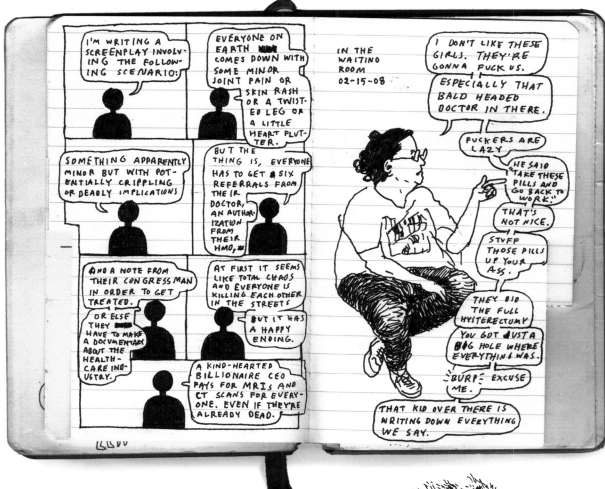

BRIAN CHIPPENDALE

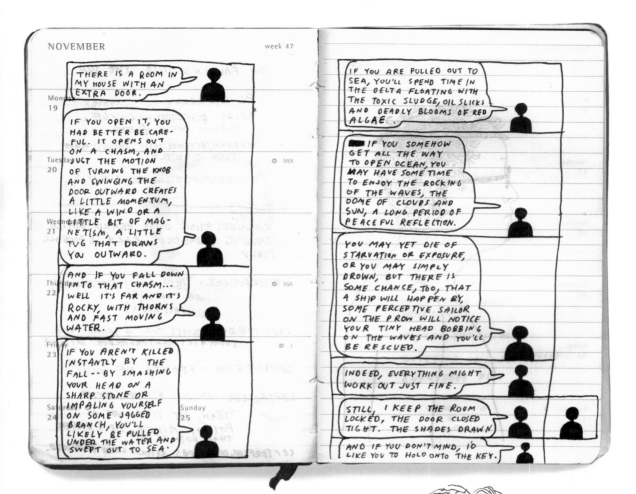

MOLLIE GOLDSTROM

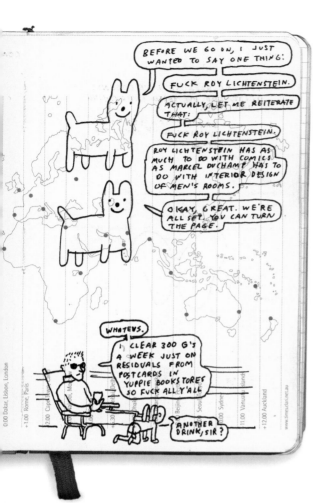

HEARD ON THE STREET:

A WOMAN AND MAN WALKING TOGETHER, EXCEPT THAT SHE'S A LITTLE AHEAD OF HIM AND THEY BOTH SEEM A BIT AGITATED

HIM: "FINE I'LL COME OVER AND ASK YOUR HUSBAND FOR MY SHIRT BACK."

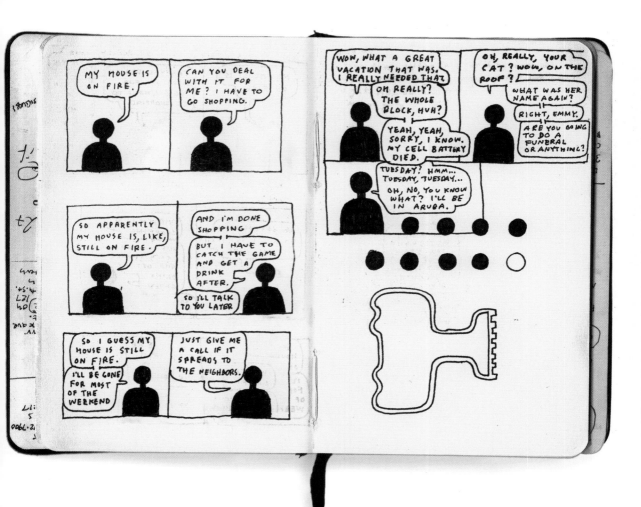

13

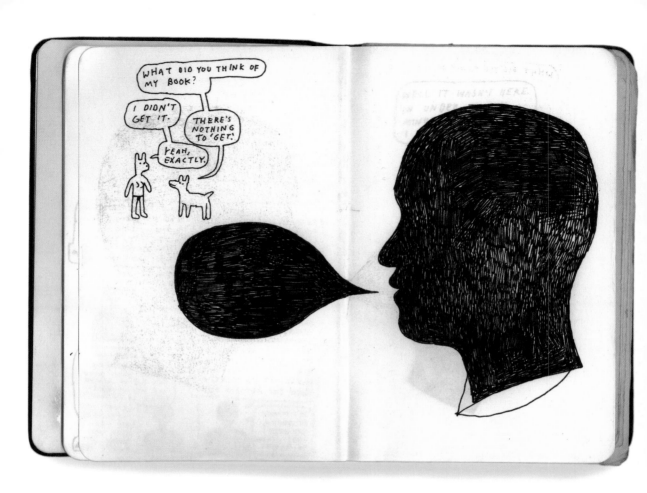

IF YOU AREN'T COMPLETELY CONFUSED AND HORRIFIED, YOU AREN'T PAYING ATTENTION.

SLAVOJ ZIZEK SAYS THAT INSTEAD OF MAKING INFINITE, IMPOSSIBLE DEMANDS ON A CORRUPT, CAPITALIST STATE, LIKE, FOR UNIVERSAL HEALTH CARE, AN END TO THE WAR IN IRAQ, A REASONABLE RESPONSE TO GLOBAL WARMING...

SINCE THEIR REACTION IS PREDICTABLY: "AH, THANK YOU FOR YOUR SUGGESTION, YES, THAT WOULD BE NICE, TOO BAD IT JUST CAN'T HAPPEN."

INSTEAD, HE SAYS, WE OUGHT TO MAKE LIMITED, FINITE DEMANDS THAT CAN'T BE MET WITH THE SAME ANSWER.

HE SAYS SOMETHING ABOUT HUGO CHAVEZ IN THIS REGARD, BUT I DON'T THINK I ENTIRELY GET HIS POINT, AND THEN THE ARTICLE ENDS.

SOMEONE SHOULD KIDNAP GEORGE BUSH ONCE HE'S OUT OF POWER AND HIS SECURITY DETAIL IS SMALLER AND CUT OFF ONE FINGER EACH WEEK UNTIL THE GLACIERS COME BACK.

SO I MIGHT BE WRONG, BUT HERE'S WHAT I THINK HE MEANS:

JUST ▮ REMEMBER: POETRY IS USELESS.

YOU ARE A BEAST, AN ANIMAL, SNUFFLING IN THE DIRT.

THIS THEORY YOU HAVE, THAT YOU WERE FORMED FROM THE CLAY BY THE HAND OF GOD, GIVEN SPECIAL ATTENTION, ▮ YOUR LIFE BREATHED INTO YOU BY HIS VERY BREATH: IT'S A FICTION

YOU ARE NO DIFFERENT THAN THE INSECTS, THE WORMS, SOME FERAL DOG.

IN FACT, THE VERY CONCEIT AT THE HEART OF YOUR ▮ THEORY ▮ DEBASES EVEN THIS LOWLY STATUS.

NO WORM THINKS IT WAS MADE IN THE IMAGE OF GOD.

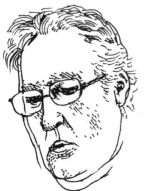

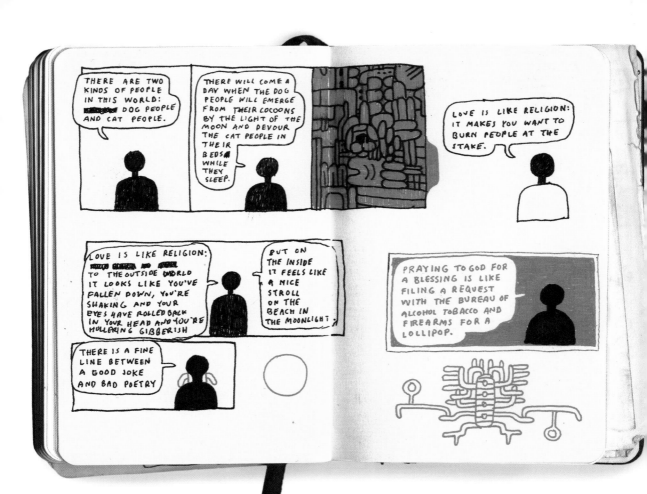

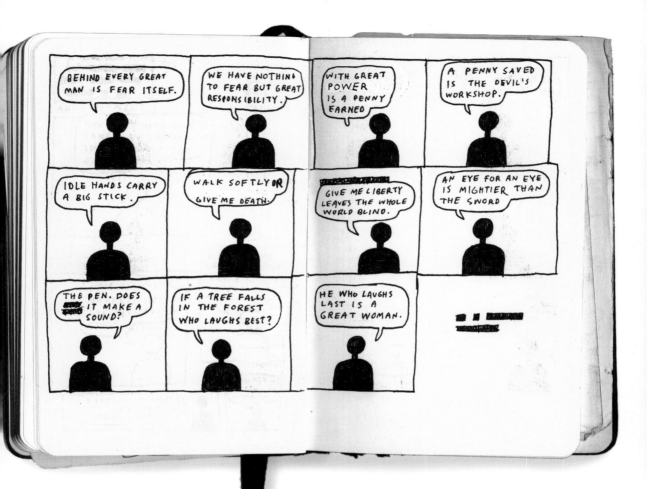

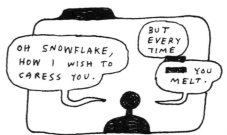

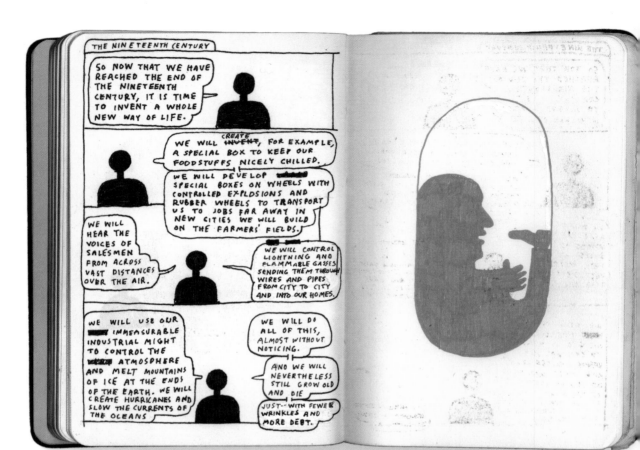

SO NOW THAT WE HAVE REACHED THE END OF THE NINETEENTH CENTURY, IT IS TIME TO INVENT A WHOLE NEW WAY OF LIFE.

WE WILL ~~INVENT~~ CREATE, FOR EXAMPLE, A SPECIAL BOX TO KEEP OUR FOODSTUFFS NICELY CHILLED.

WE WILL DEVELOP ~~SPECIAL~~ SPECIAL BOXES ON WHEELS WITH CONTROLLED EXPLOSIONS AND RUBBER WHEELS TO TRANSPORT US TO JOBS FAR AWAY IN NEW CITIES WE WILL BUILD ON THE FARMERS' FIELDS.

WE WILL HEAR THE VOICES OF SALESMEN FROM ACROSS VAST DISTANCES OVER THE AIR.

WE WILL CONTROL LIGHTNING AND FLAMMABLE GASSES SENDING THEM THROUGH WIRES AND PIPES FROM CITY TO CITY AND INTO OUR HOMES.

WE WILL USE OUR ~~WHOLE~~ IMMEASURABLE INDUSTRIAL MIGHT TO CONTROL THE ~~VERY~~ ATMOSPHERE AND MELT MOUNTAINS OF ICE AT THE ENDS OF THE EARTH. WE WILL CREATE HURRICANES AND SLOW THE CURRENTS OF THE OCEANS

WE WILL DO ALL OF THIS, ALMOST WITHOUT NOTICING.

AND WE WILL NEVERTHELESS STILL GROW OLD AND DIE

JUST—WITH FEWER WRINKLES AND MORE DEBT.

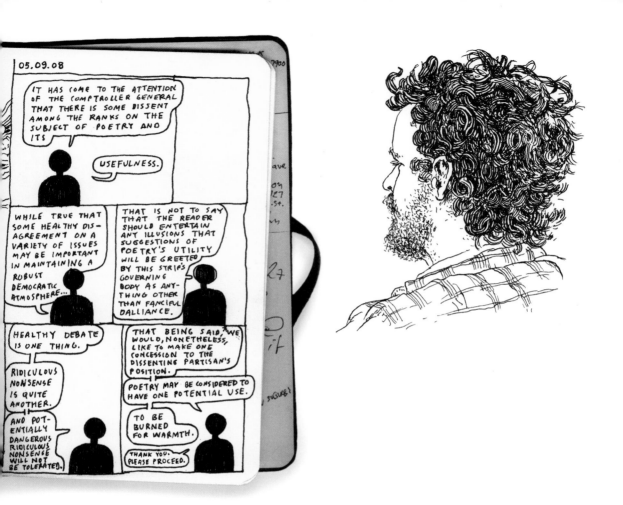

SO, WHAT'S YOUR FAVORITE FILM

well if I have to choose, I would choose "love actually" or...

oh, woody allen films

what about spanish films

oh.... I don't have one

because actually

Austin Powers

I love it because you don't have to
 think at all, just laugh,

I have a back street boys t-shirt
what is your favorite music.
...
Godspeed you black emperor
Double drum sets

it's maybe not the thing you put
 on before going out to a party, but

it's very political
it's very anti... uh... anti war industry

and showing which company...
For example the industries of
warner brothers and so on
weapons makers
ariel shanon making the 2nd intefada

I should play you some
 fantastic

this is the best
You cannot listen to the whole
song because it's 14 minutes

this is a very good record
very catchy, very catchy
they played in Helsinki 3 weeks ago
brilliant
I've seen them live 2 times
couple of months ago... radiohead?
very good, yeah.
you should go to the Rotsgild (?) festival
it was so rainy. so rainy

YOUNG AMERICAN COUPLE AT CAFE IN HELSINKI 9-08

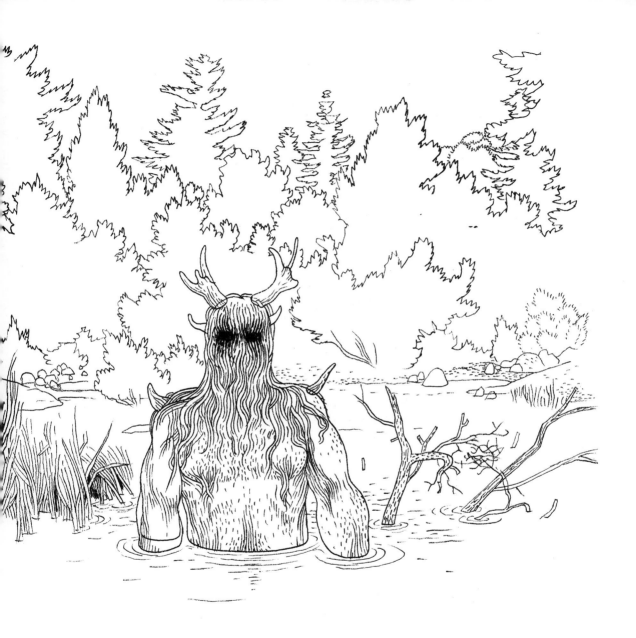

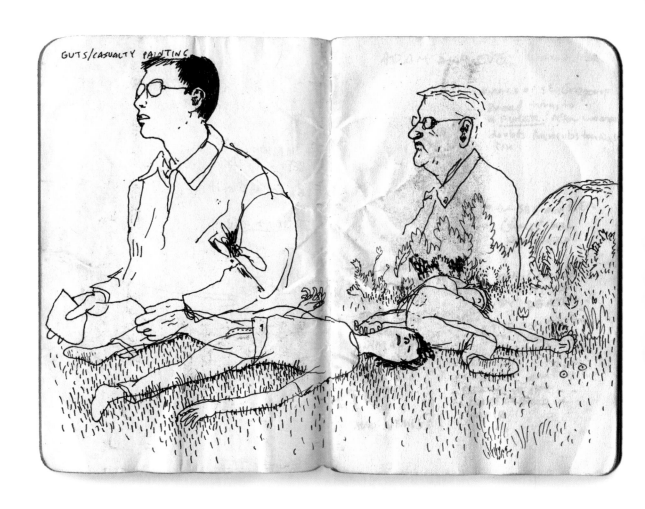

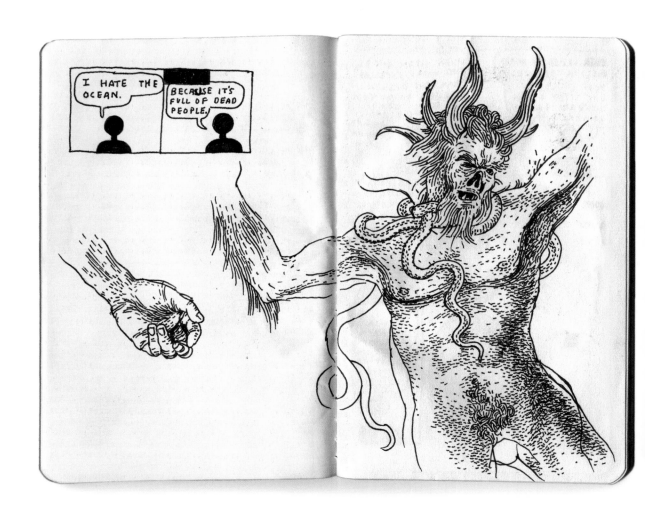

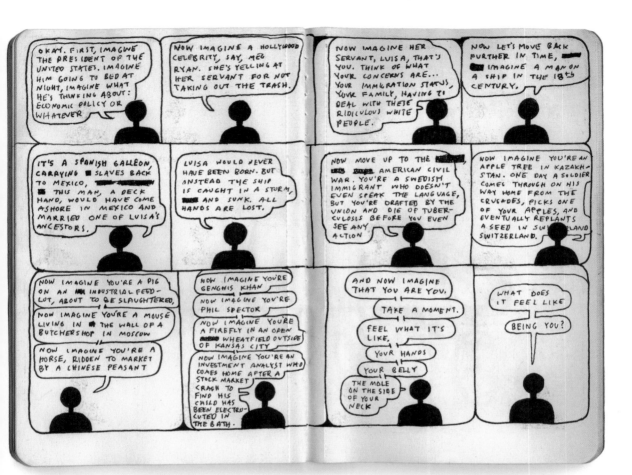

33

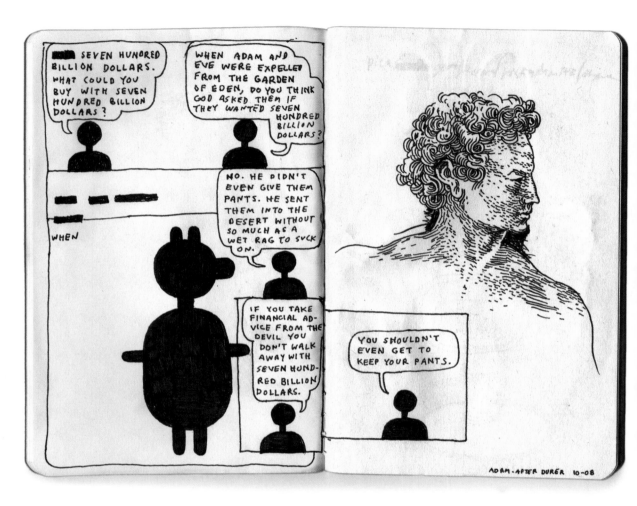

ADAM - AFTER DURER 10-08

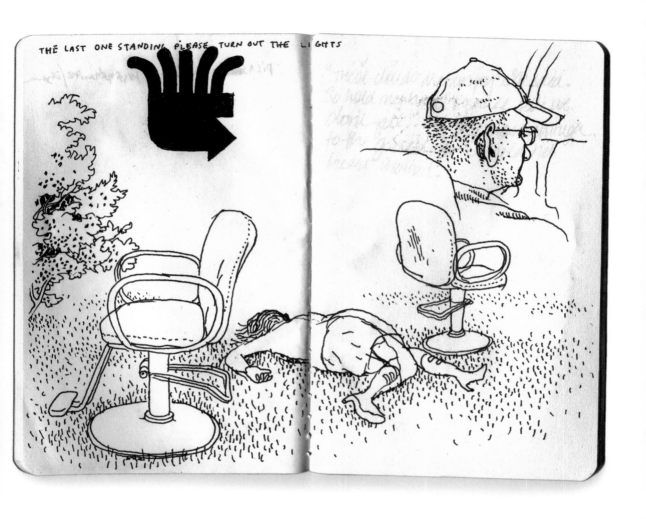

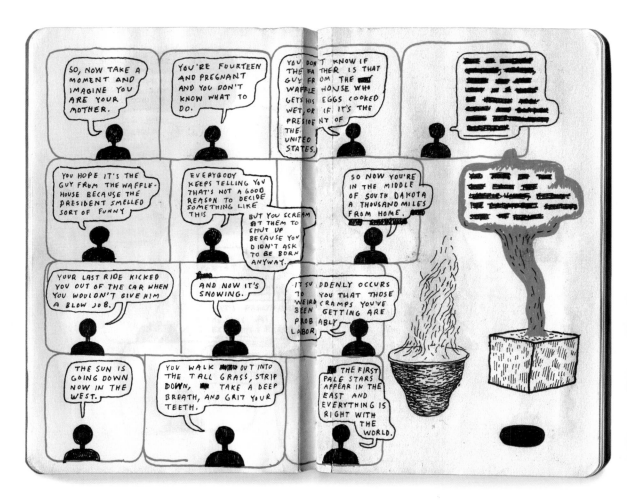

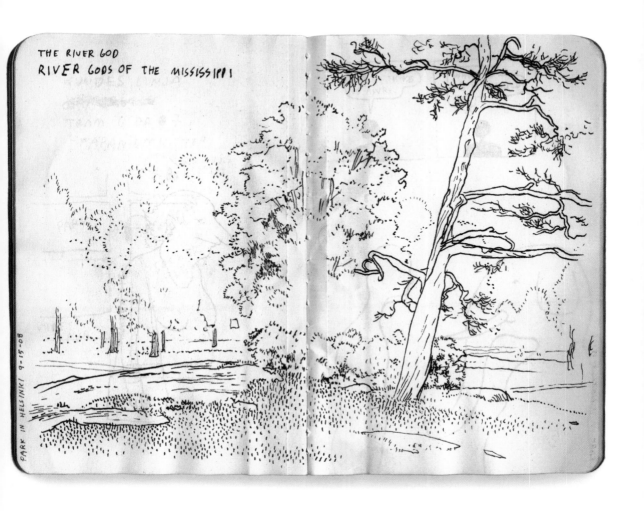

THE RIVER GOD
RIVER GODS OF THE MISSISSIPPI

PARK IN HELSINKI 9-15-08

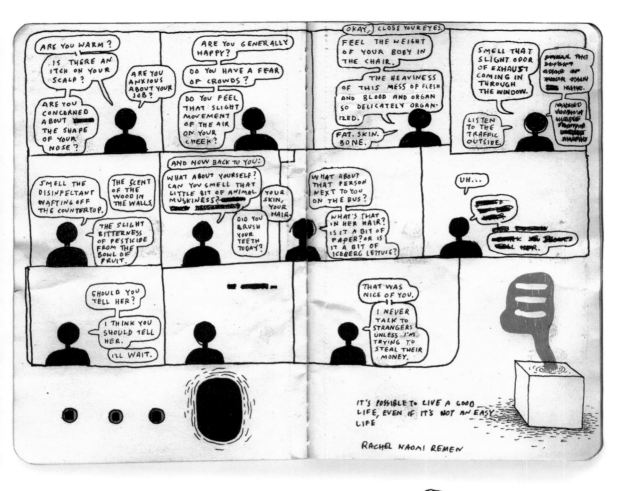

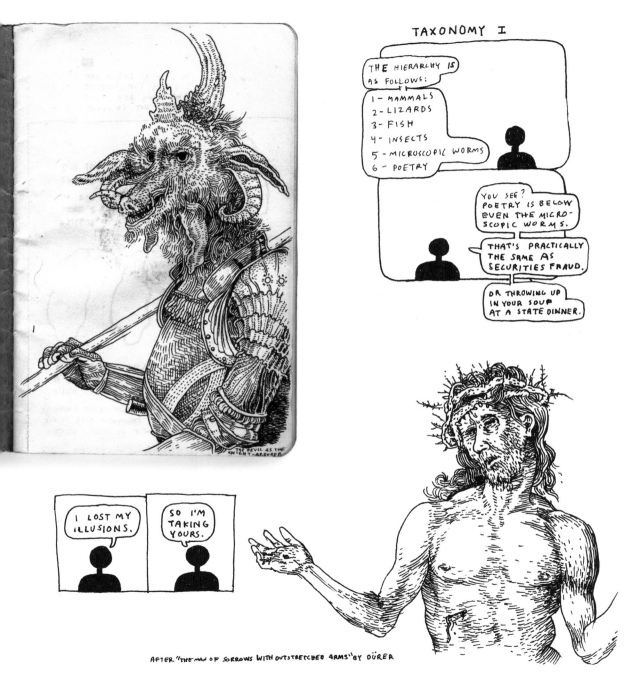

TAXONOMY I

THE HIERARCHY IS AS FOLLOWS:
1 - MAMMALS
2 - LIZARDS
3 - FISH
4 - INSECTS
5 - MICROSCOPIC WORMS
6 - POETRY

YOU SEE? POETRY IS BELOW EVEN THE MICRO-SCOPIC WORMS.

THAT'S PRACTICALLY THE SAME AS SECURITIES FRAUD.

OR THROWING UP IN YOUR SOUP AT A STATE DINNER.

THE DEVIL AS THE KNIGHT - AF. DÜRER

I LOST MY ILLUSIONS.

SO I'M TAKING YOURS.

AFTER "THE MAN OF SORROWS WITH OUTSTRETCHED ARMS" BY DÜRER

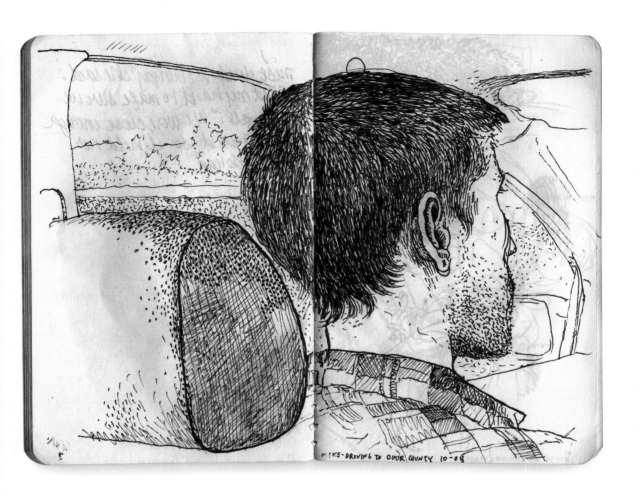

MIKE - DRIVING TO DOOR COUNTY 10-08

41

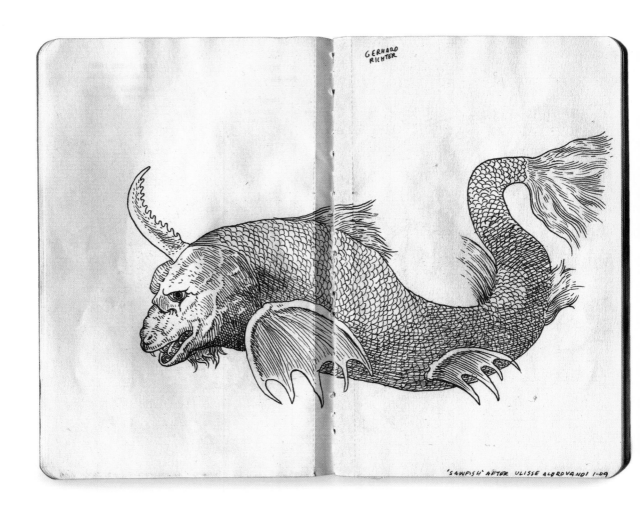

GERHARD
RICHTER

'SAWFISH' AFTER ULISSE ALDROVANDI 1-09

THE GRASS IS ALWAYS GREENER ON THE HAND THAT FEEDS.

I THINK, THEREFORE THE FAT LADY SINGS.

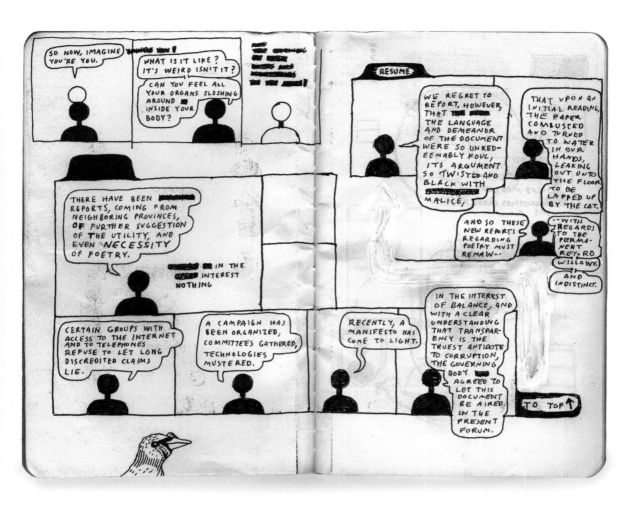

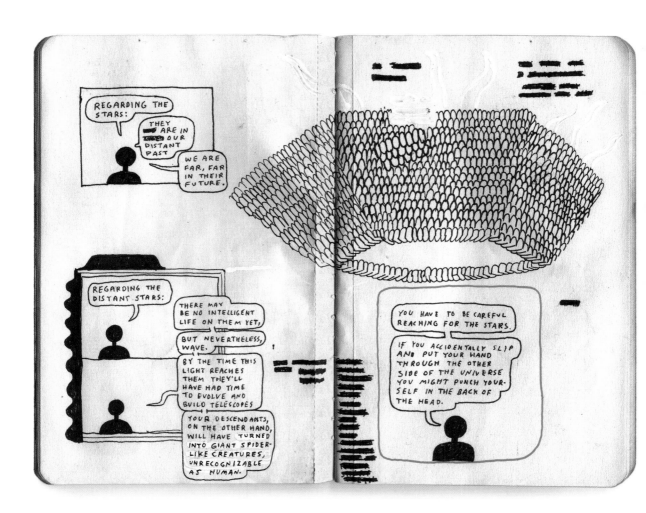

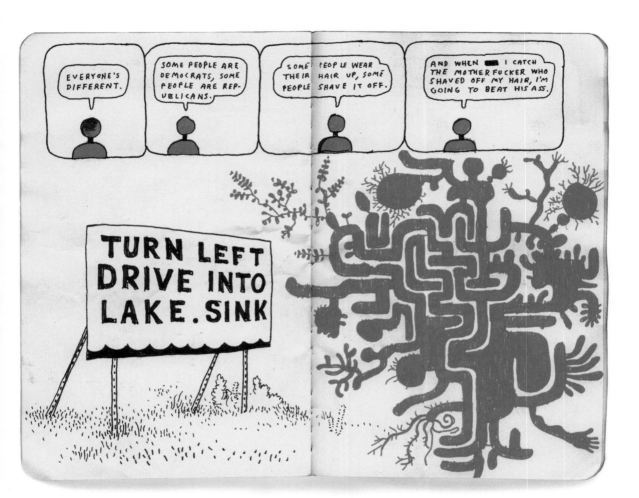

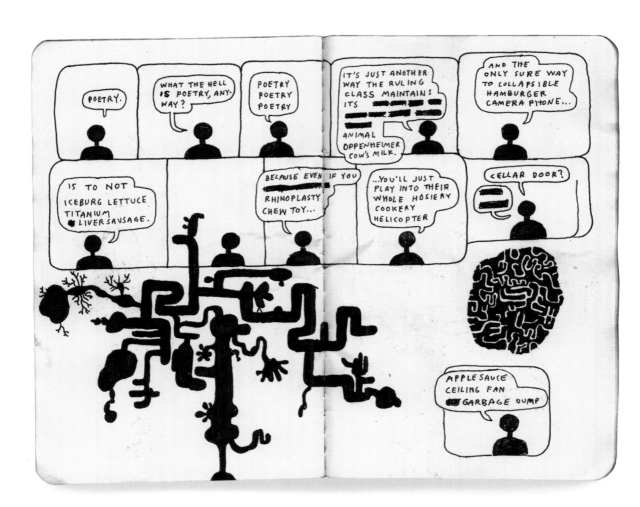

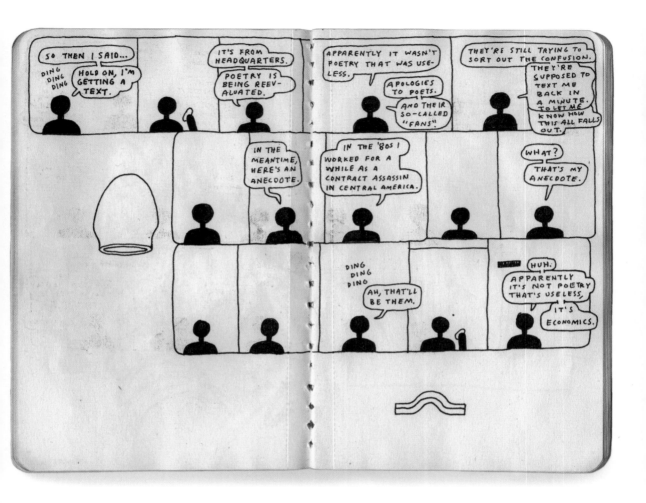

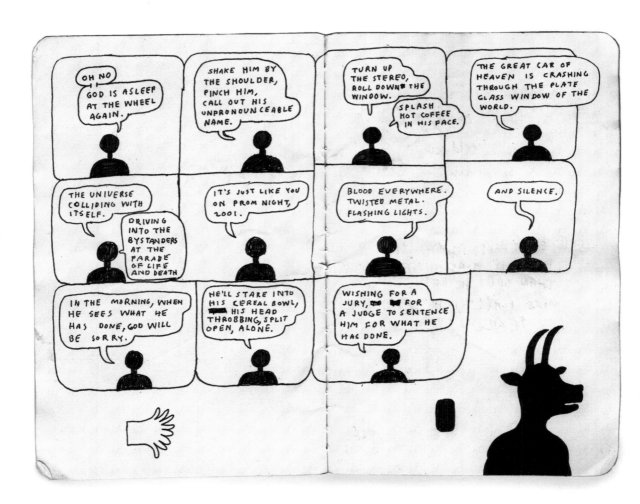

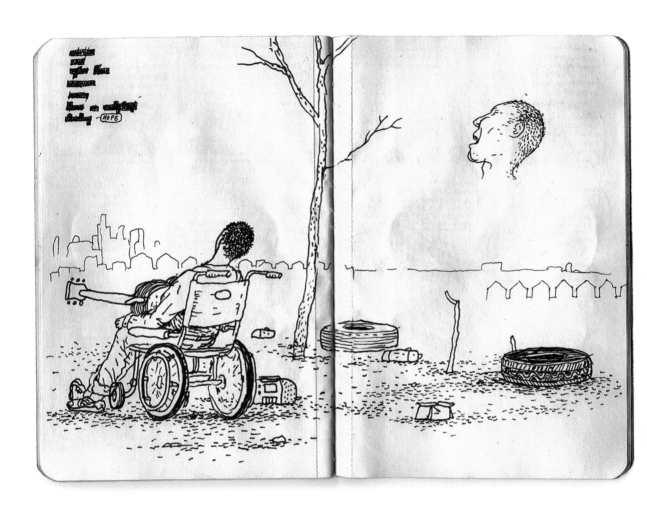

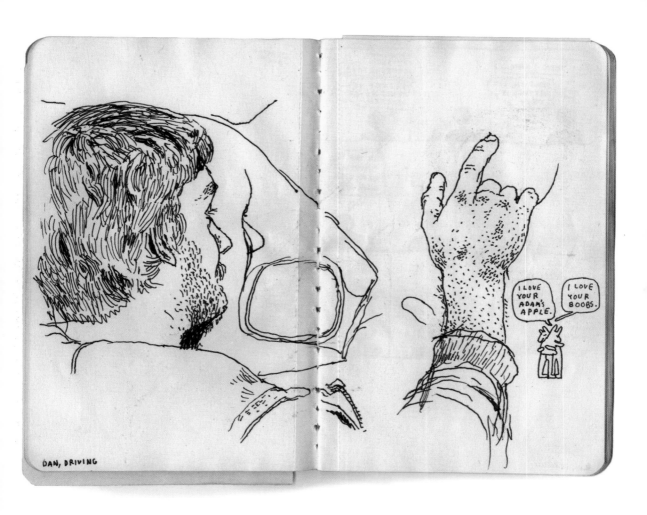

DAN, DRIVING

51

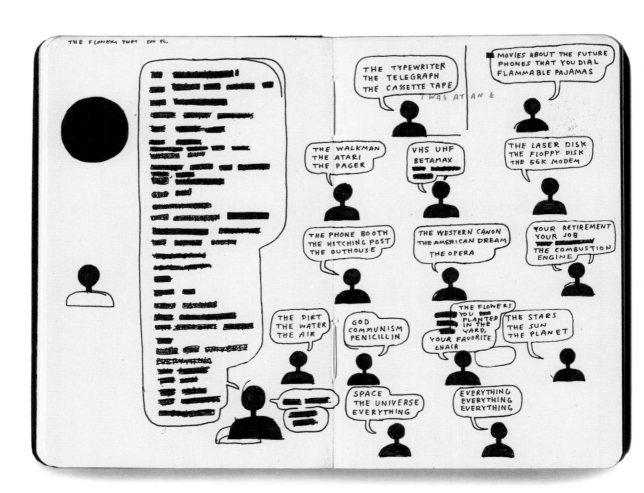

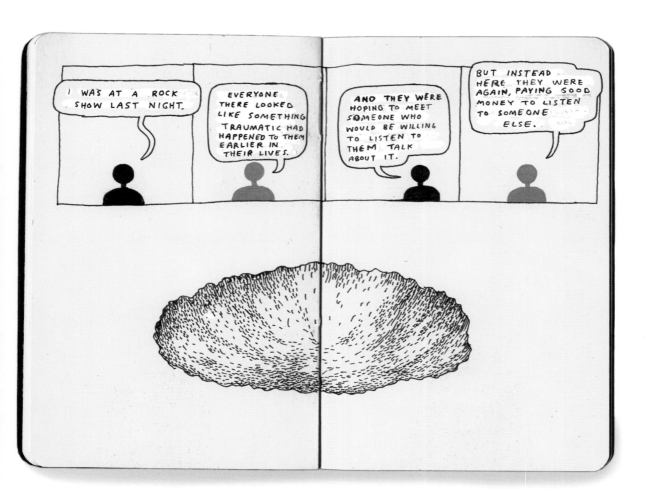

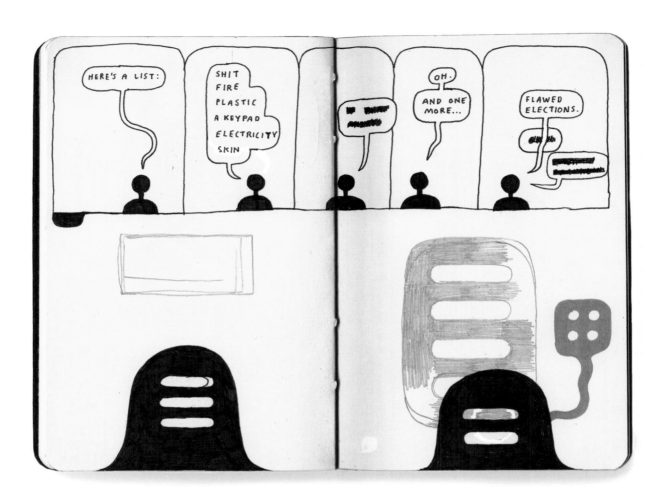

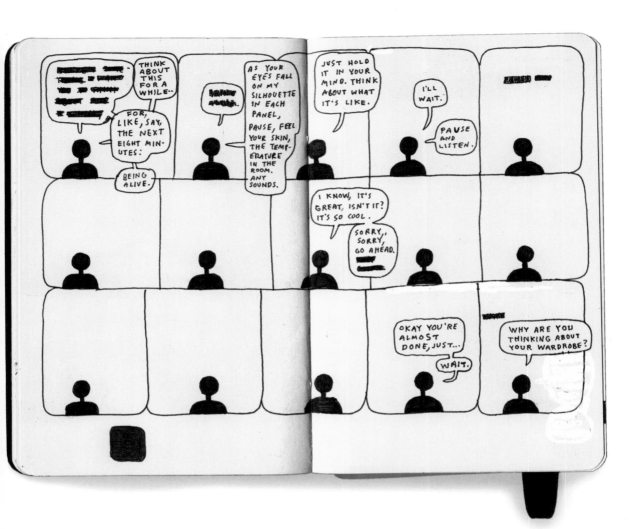

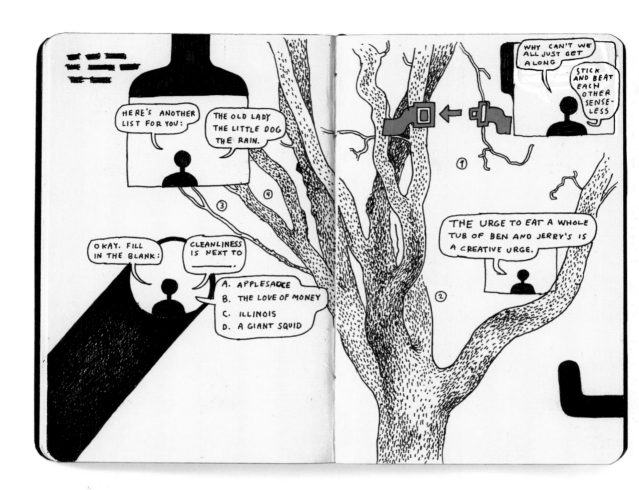

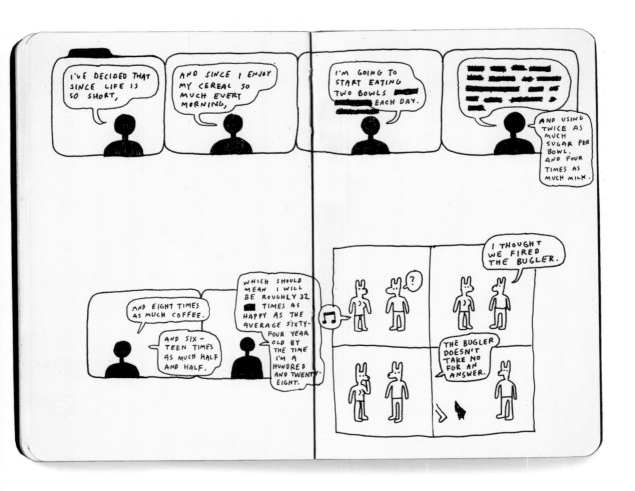

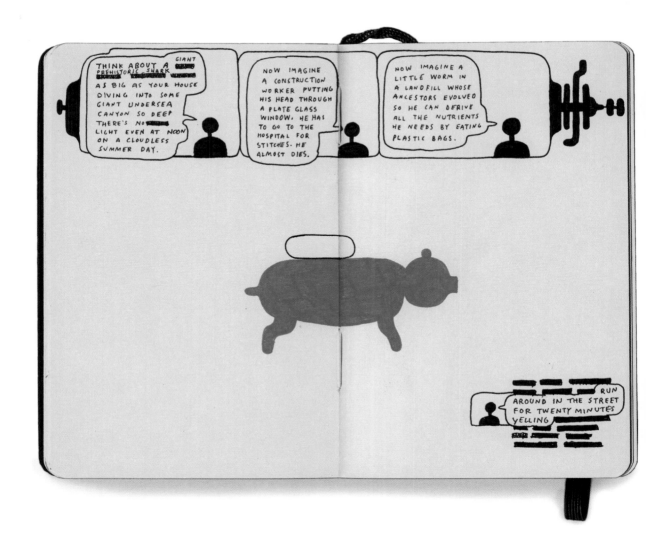

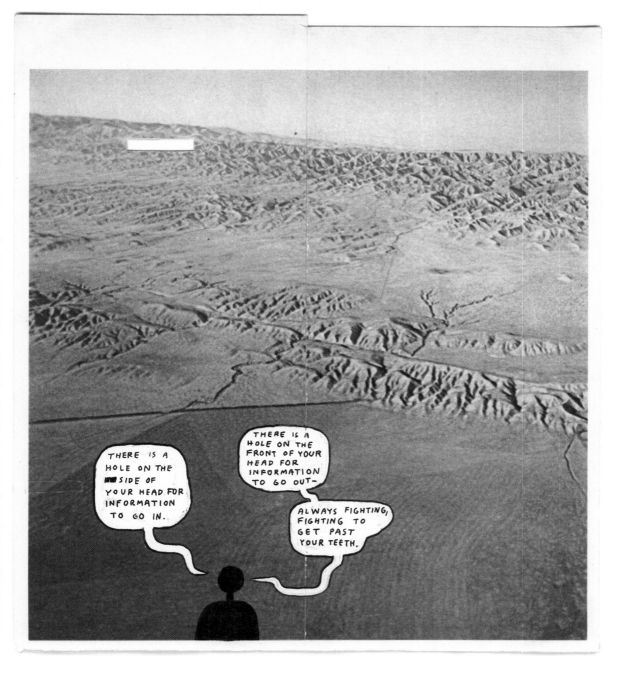

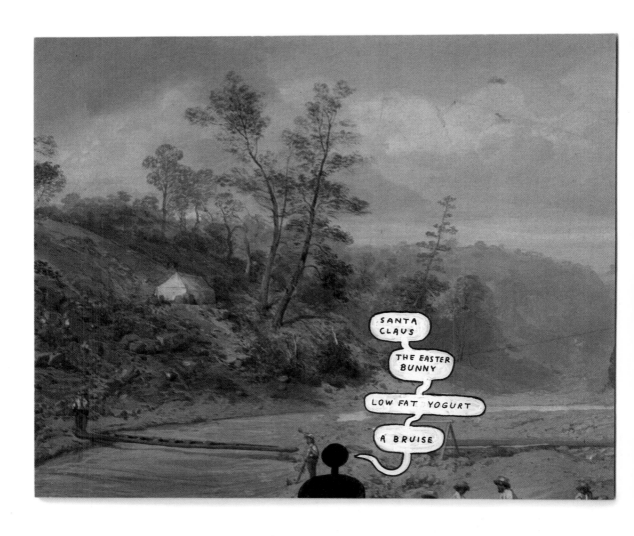

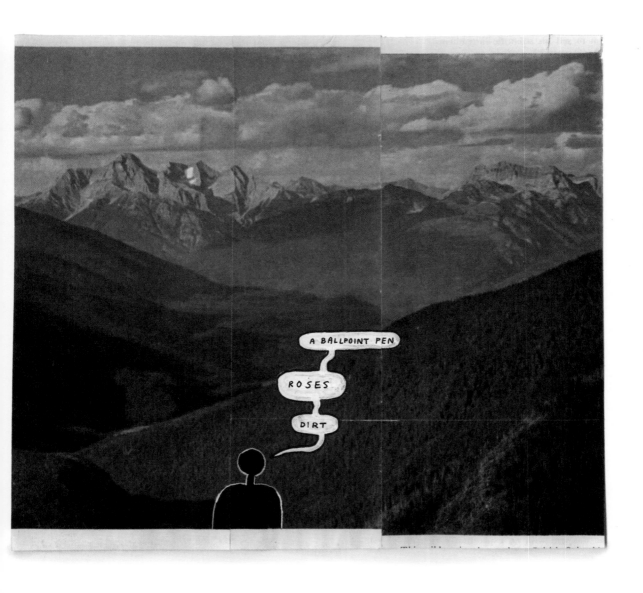

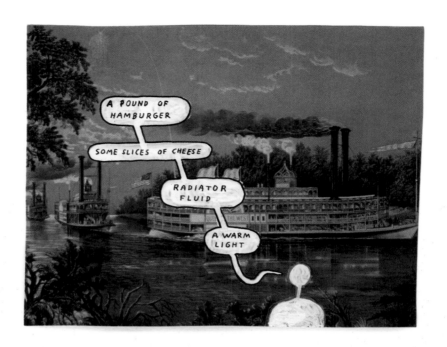

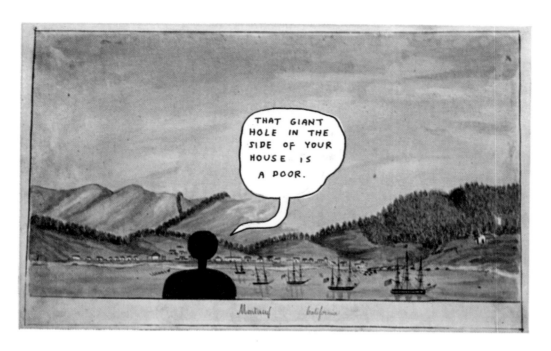

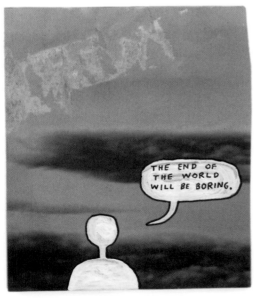

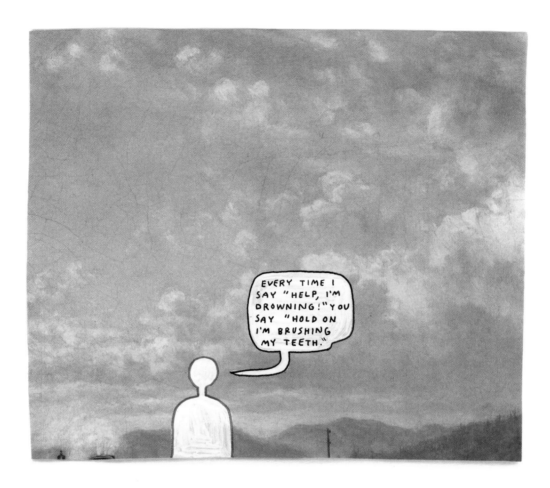

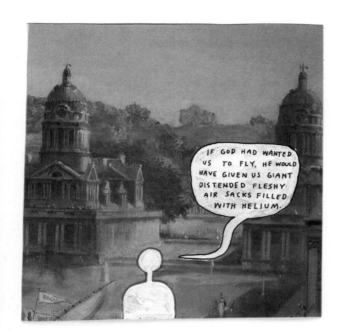

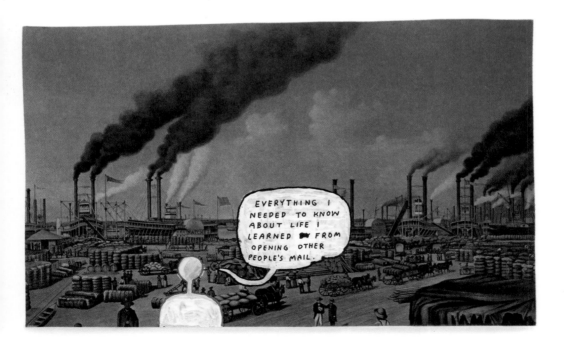

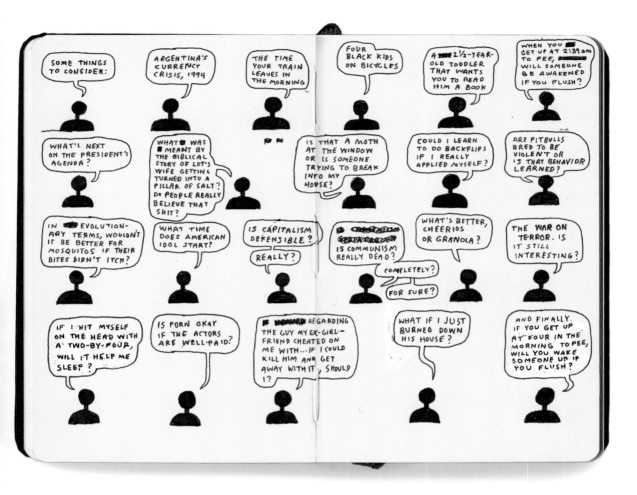

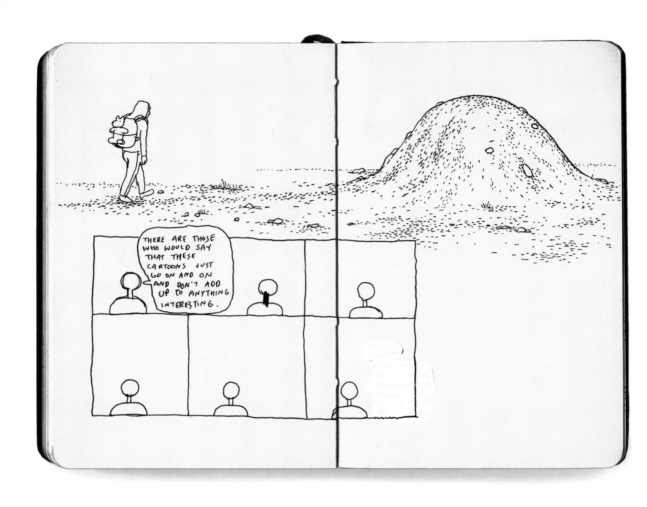

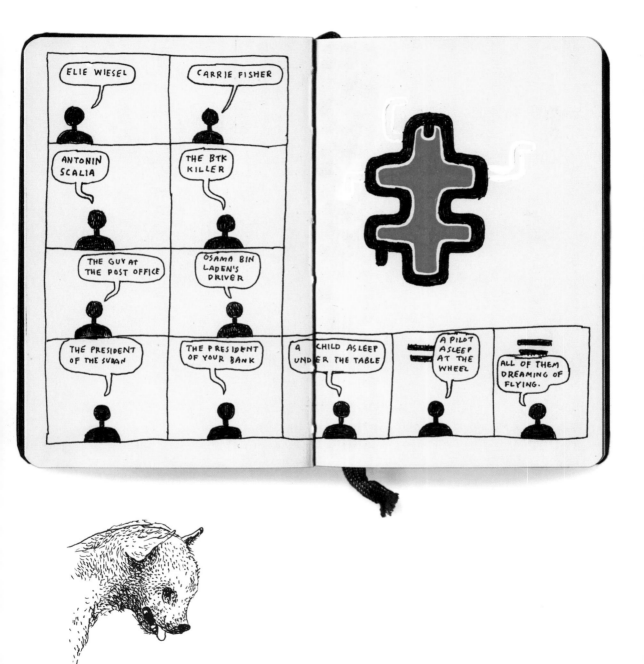

69

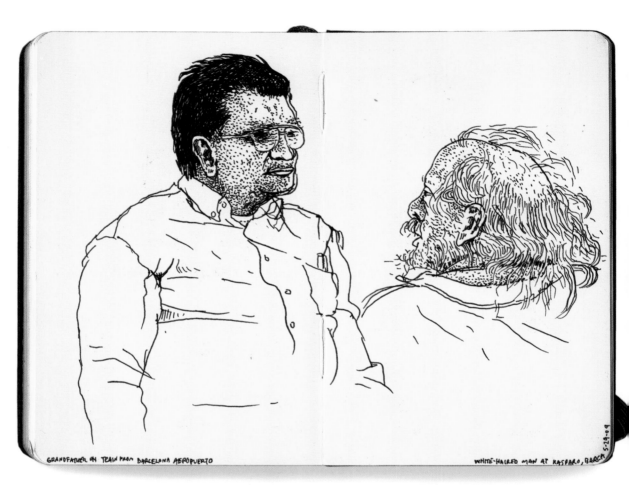

GRANDFATHER ON TRAIN FROM BARCELONA AEROPUERTO

WHITE-HAIRED MAN AT KASPARO, BARCA

5-29-09

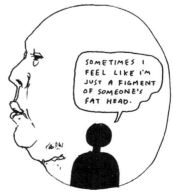

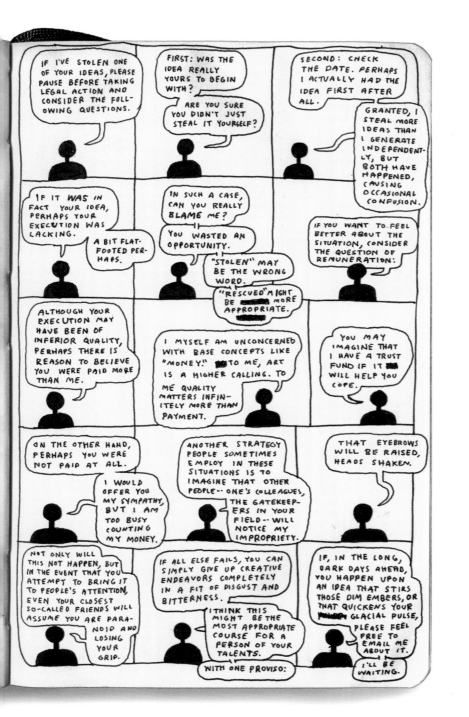

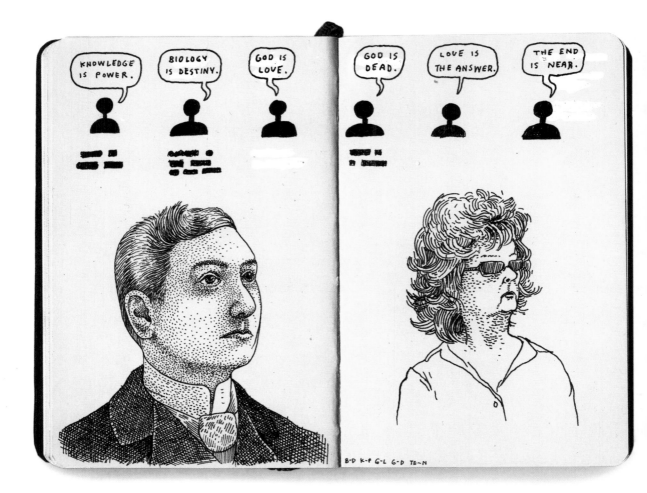

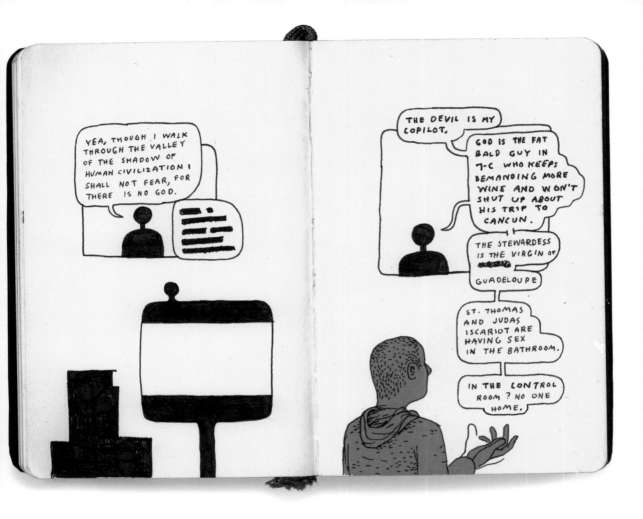

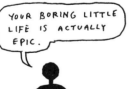

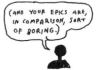

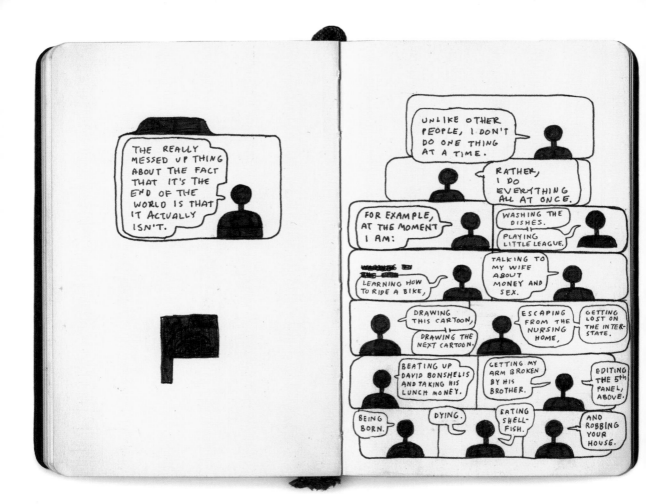

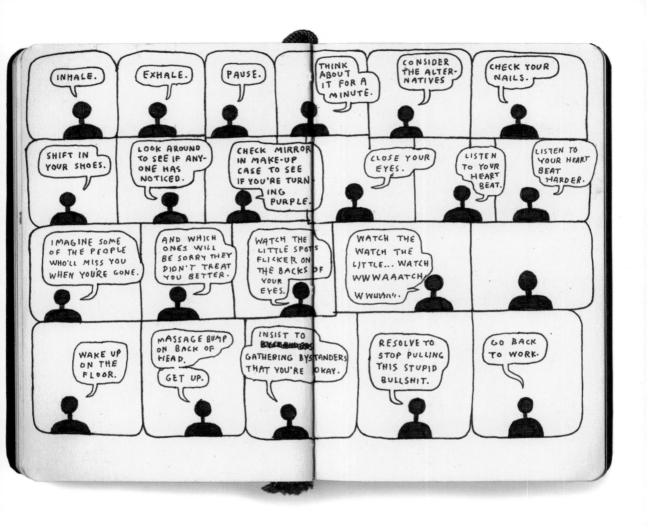

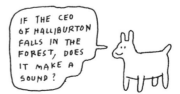

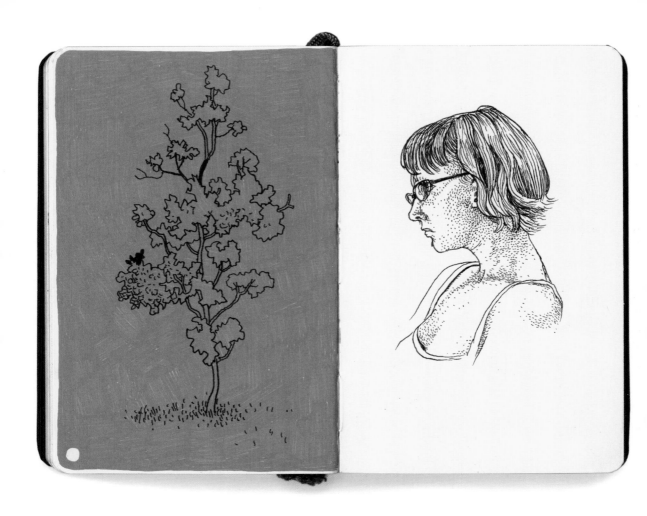

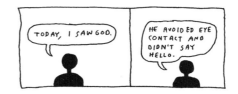

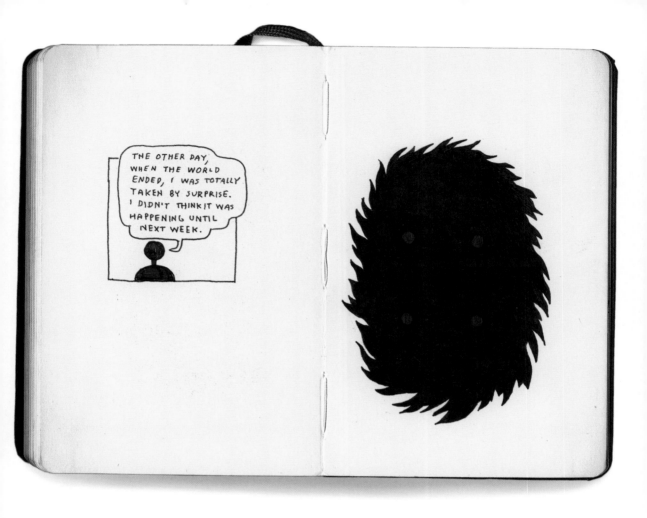

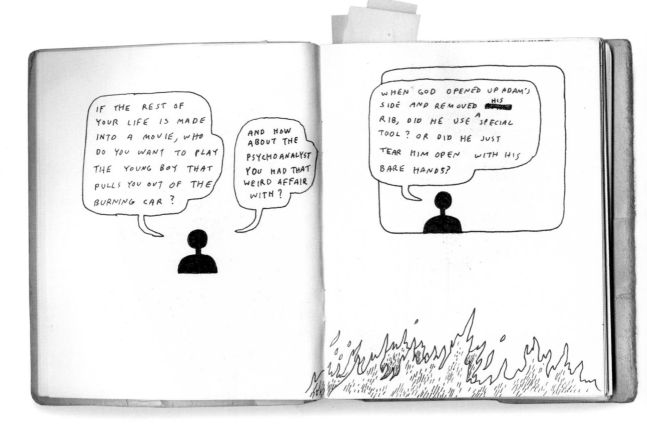

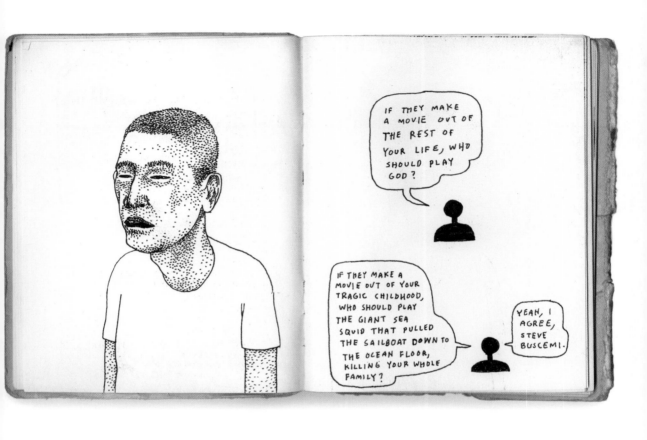

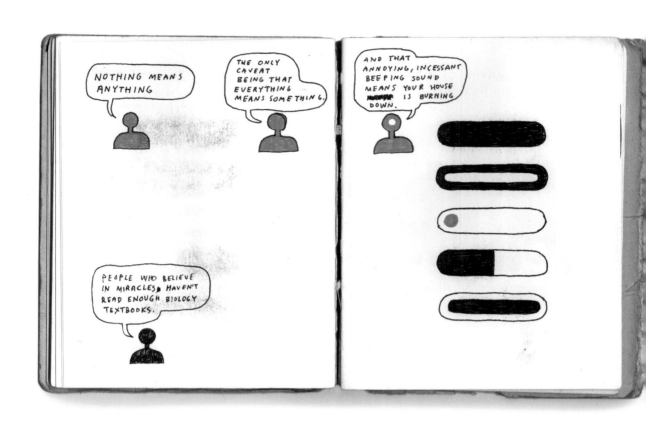

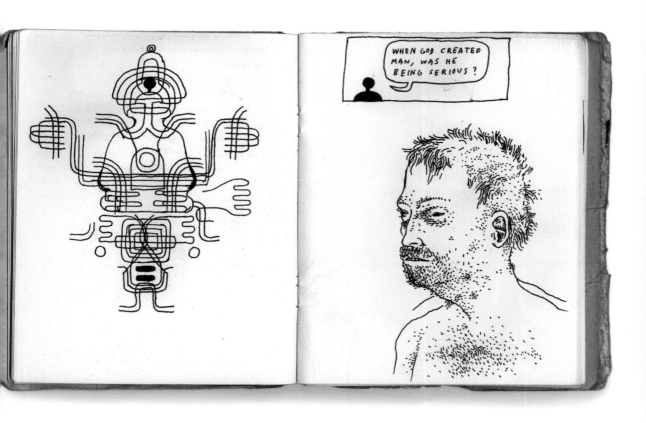

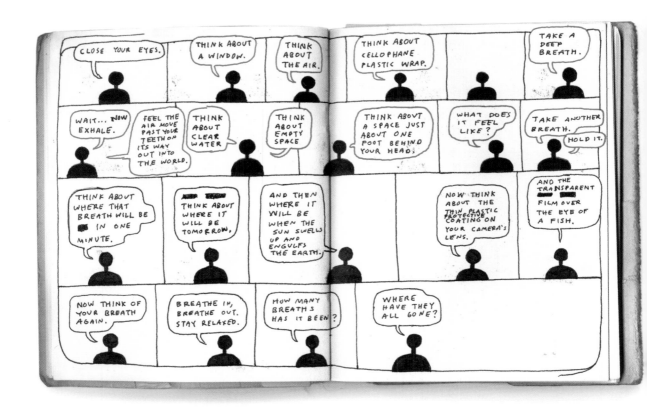

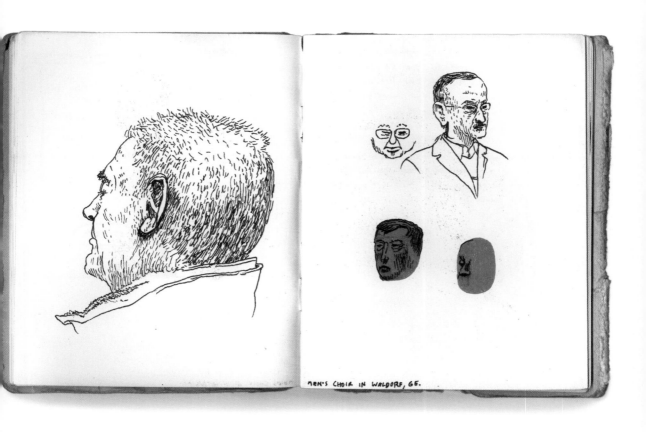

MEN'S CHOIR IN WALDORF, GE.

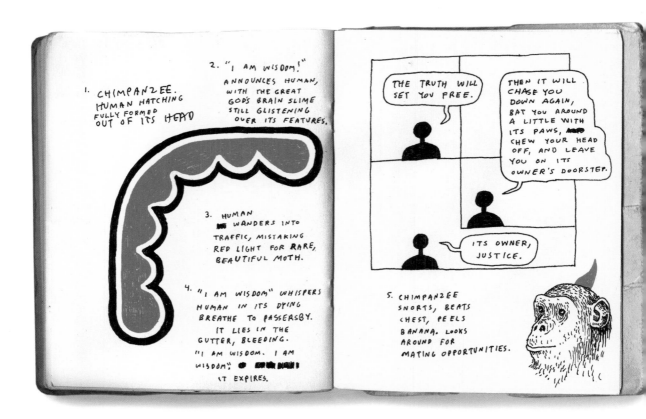

1. CHIMPANZEE. HUMAN HATCHING FULLY FORMED OUT OF ITS HEAD

2. "I AM WISDOM!" ANNOUNCES HUMAN, WITH THE GREAT GOD'S BRAIN SLIME STILL GLISTENING OVER ITS FEATURES.

3. HUMAN WANDERS INTO TRAFFIC, MISTAKING RED LIGHT FOR RARE, BEAUTIFUL MOTH.

4. "I AM WISDOM" WHISPERS HUMAN IN ITS DYING BREATHE TO PASSERSBY. IT LIES IN THE GUTTER, BLEEDING. "I AM WISDOM. I AM WISDOM." IT EXPIRES.

THE TRUTH WILL SET YOU FREE.

THEN IT WILL CHASE YOU DOWN AGAIN, BAT YOU AROUND A LITTLE WITH ITS PAWS, CHEW YOUR HEAD OFF, AND LEAVE YOU ON ITS OWNER'S DOORSTEP.

ITS OWNER, JUSTICE.

5. CHIMPANZEE SNORTS, BEATS CHEST, PEELS BANANA. LOOKS AROUND FOR MATING OPPORTUNITIES.

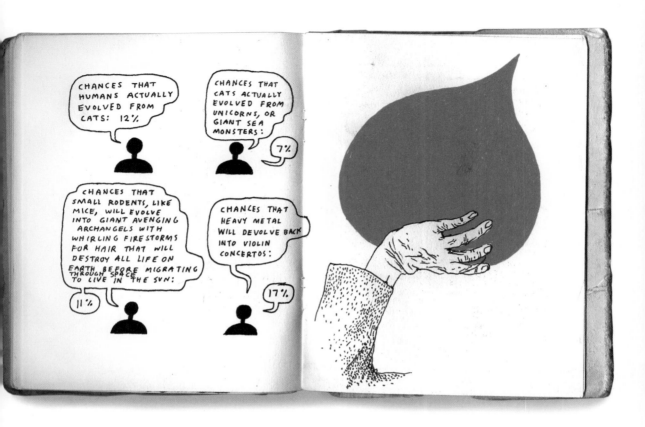

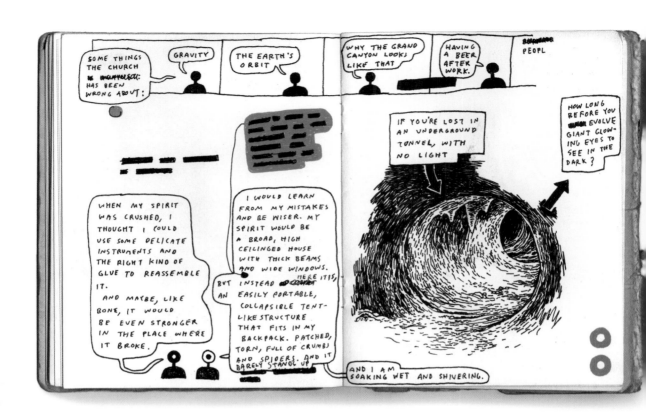

SOME THINGS THE CHURCH HAS BEEN WRONG ABOUT:

GRAVITY

THE EARTH'S ORBIT

WHY THE GRAND CANYON LOOKS LIKE THAT

HAVING A BEER AFTER WORK.

PEOPL

WHEN MY SPIRIT WAS CRUSHED, I THOUGHT I COULD USE SOME DELICATE INSTRUMENTS AND THE RIGHT KIND OF GLUE TO REASSEMBLE IT.
AND MAYBE, LIKE BONE, IT WOULD BE EVEN STRONGER IN THE PLACE WHERE IT BROKE.

I WOULD LEARN FROM MY MISTAKES AND BE WISER. MY SPIRIT WOULD BE A BROAD, HIGH CEILINGED HOUSE WITH THICK BEAMS AND WIDE WINDOWS. HERE IT IS, BUT INSTEAD, AN EASILY PORTABLE, COLLAPSIBLE TENT-LIKE STRUCTURE THAT FITS IN MY BACKPACK. PATCHED, TORN, FULL OF CRUMBS AND SPIDERS. AND IT BARELY STANDS UP

IF YOU'RE LOST IN AN UNDERGROUND TUNNEL, WITH NO LIGHT

HOW LONG BEFORE YOU EVOLVE GIANT GLOWING EYES TO SEE IN THE DARK?

AND I AM SOAKING WET AND SHIVERING.

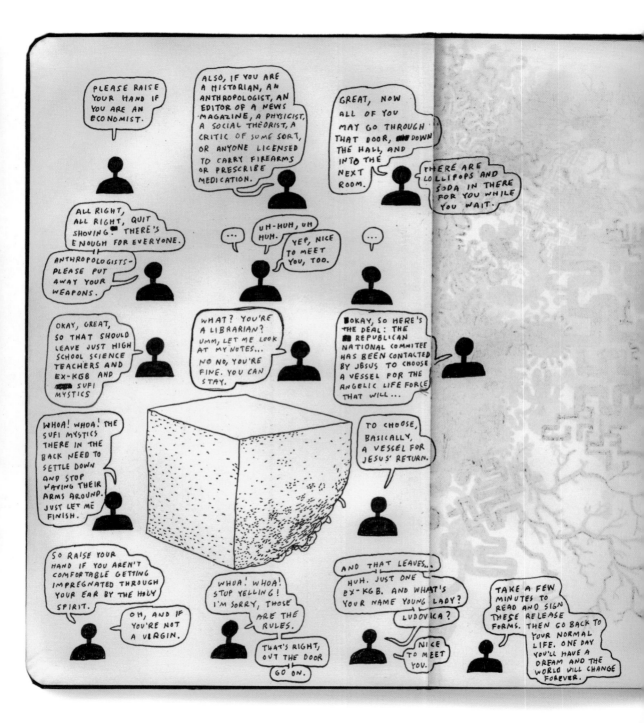

MATT
GROENING

LYNDA BARRY

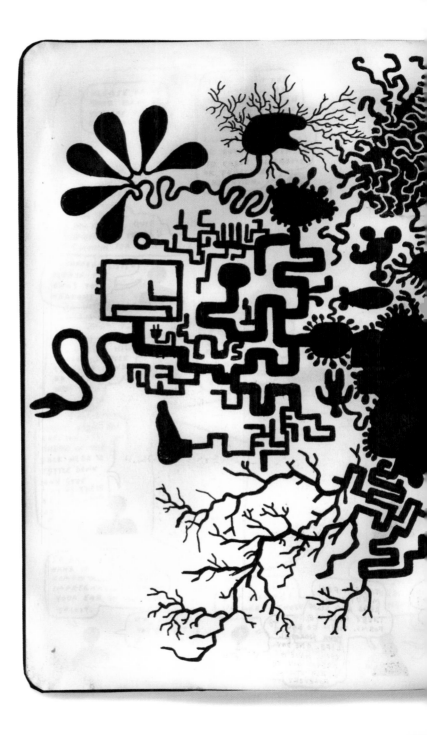

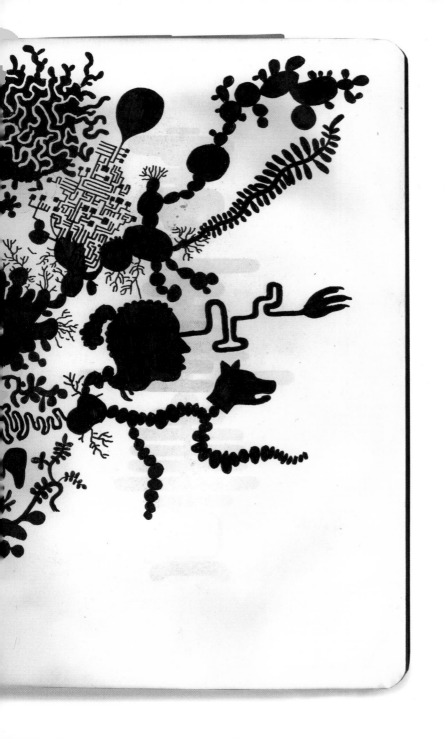

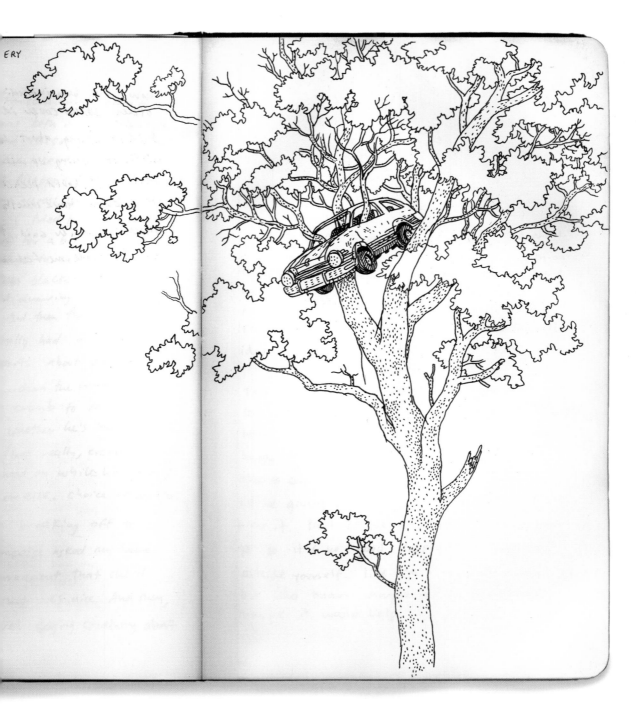

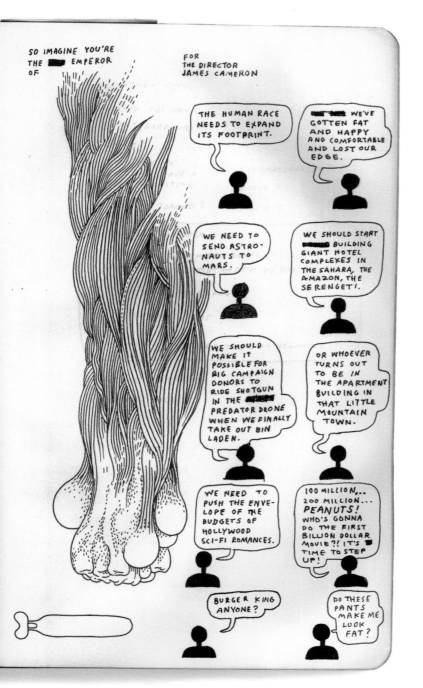

SO IMAGINE YOU'RE THE ███ EMPEROR OF

FOR
THE DIRECTOR
JAMES CAMERON

THE HUMAN RACE NEEDS TO EXPAND ITS FOOTPRINT.

███ ███ WE'VE GOTTEN FAT AND HAPPY AND COMFORTABLE AND LOST OUR EDGE.

WE NEED TO SEND ASTRONAUTS TO MARS.

WE SHOULD START ███████ BUILDING GIANT HOTEL COMPLEXES IN THE SAHARA, THE AMAZON, THE SERENGETI.

WE SHOULD MAKE IT POSSIBLE FOR BIG CAMPAIGN DONORS TO RIDE SHOTGUN IN THE ███████ PREDATOR DRONE WHEN WE FINALLY TAKE OUT BIN LADEN.

OR WHOEVER TURNS OUT TO BE IN THE APARTMENT BUILDING IN THAT LITTLE MOUNTAIN TOWN.

WE NEED TO PUSH THE ENVELOPE OF THE BUDGETS OF HOLLYWOOD SCI-FI ROMANCES.

100 MILLION,.. 200 MILLION... PEANUTS! WHO'S GONNA DO THE FIRST BILLION DOLLAR MOVIE?! IT'S ███ TIME TO STEP UP!

BURGER KING ANYONE?

DO THESE PANTS MAKE ME LOOK FAT?

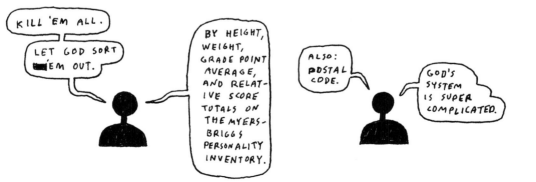

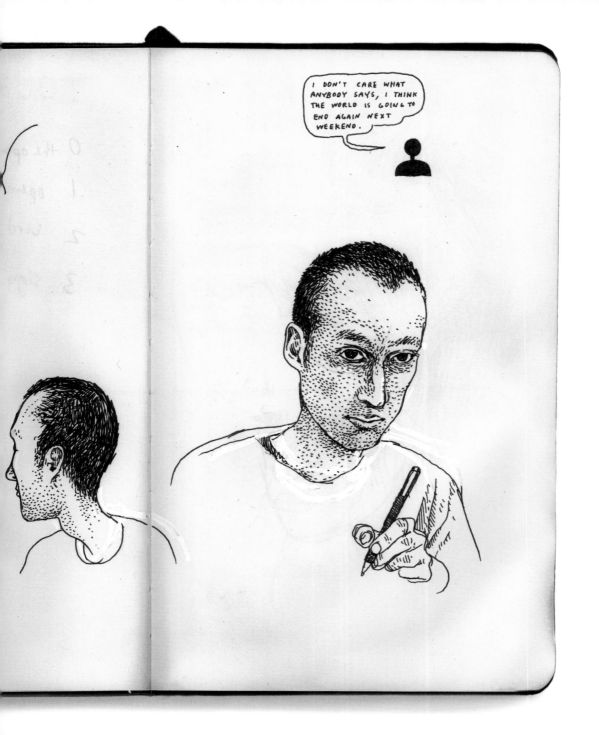

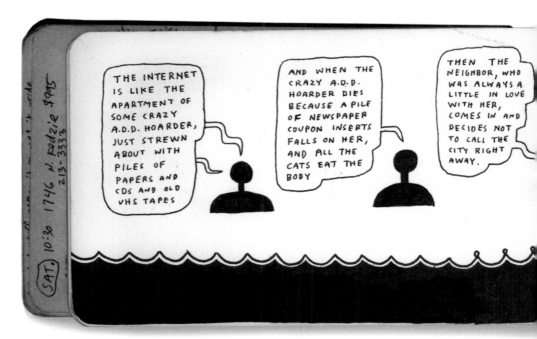

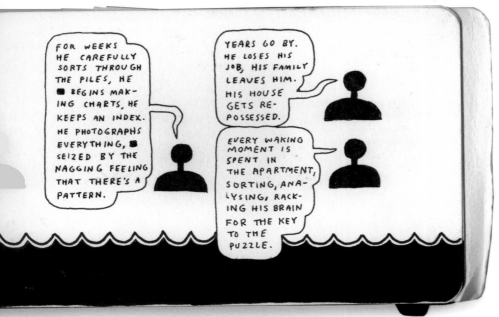

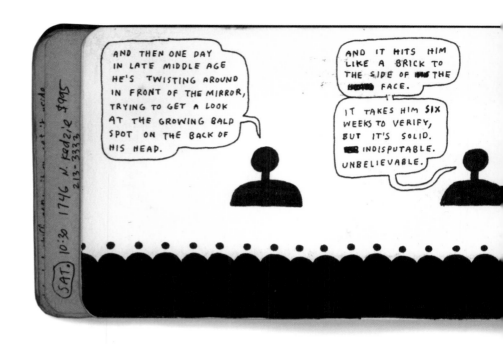

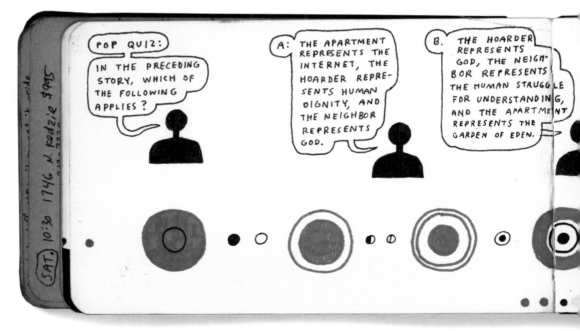

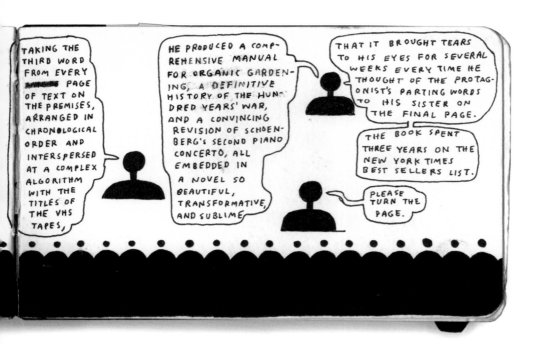

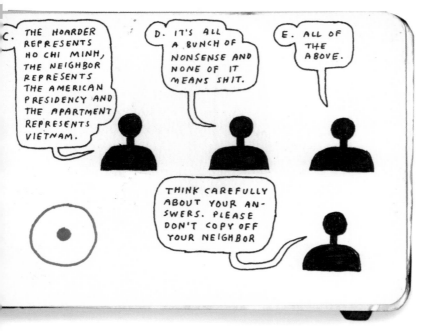

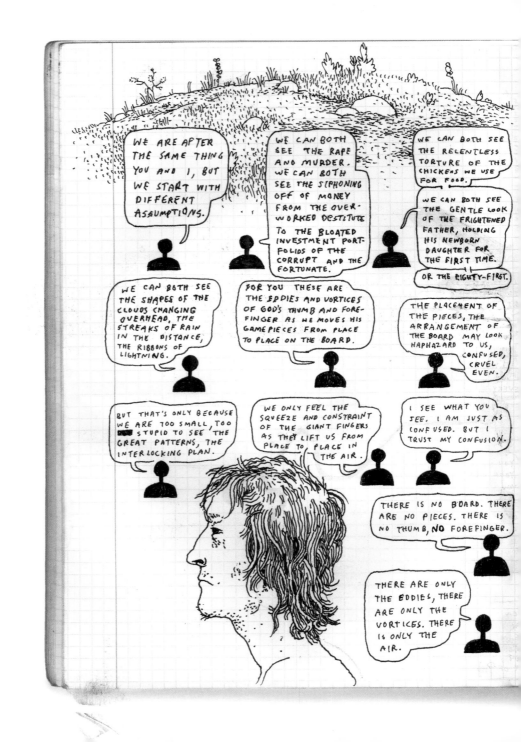

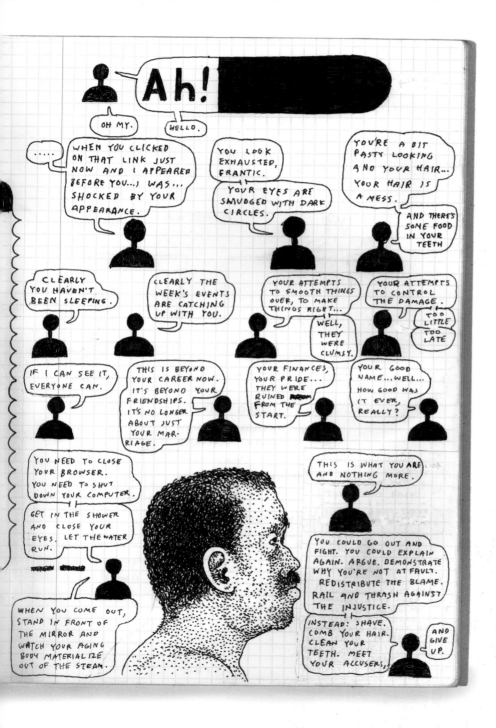

99

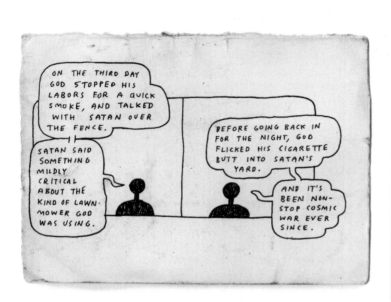

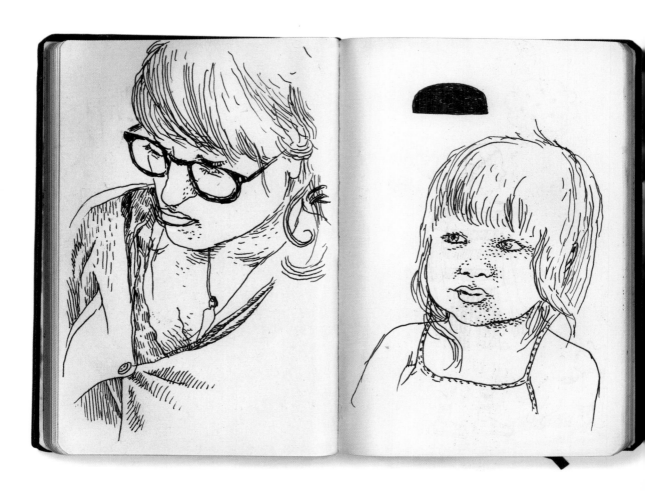

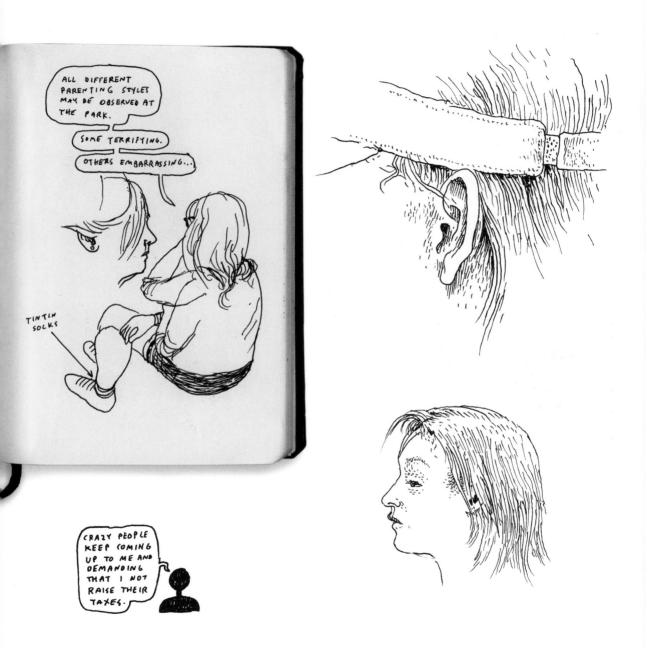

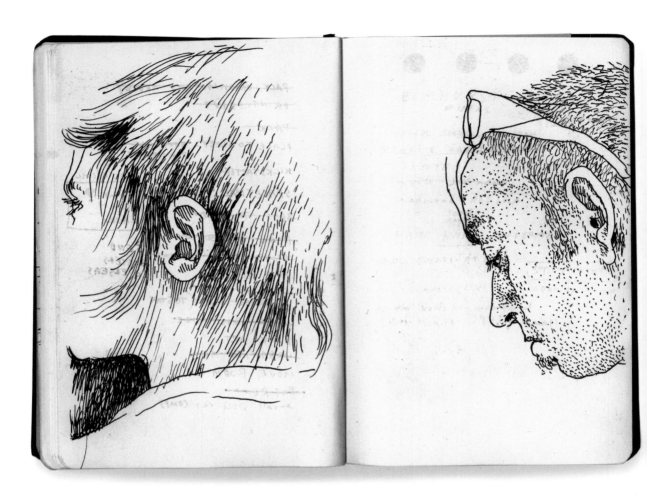

THE DAY BEFORE I LEFT I GOT UP IN THE MORNING AND THERE WAS A PARAKEET IN MY LIVING ROOM.

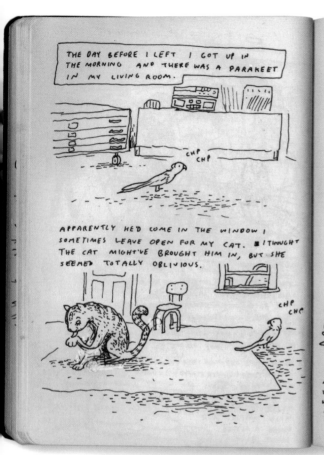

APPARENTLY HE'D COME IN THE WINDOW I SOMETIMES LEAVE OPEN FOR MY CAT. I THOUGHT THE CAT MIGHT'VE BROUGHT HIM IN, BUT SHE SEEMED TOTALLY OBLIVIOUS.

SARA WAS VERY EXCITED. SHE'S A BIRD PERSON

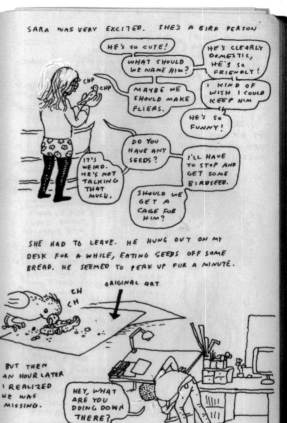

HE'S SO CUTE!

WHAT SHOULD WE NAME HIM?

HE'S CLEARLY DOMESTIC, HE'S SO FRIENDLY!

MAYBE WE SHOULD MAKE FLIERS.

I KIND OF WISH I COULD KEEP HIM

HE'S SO FUNNY!

IT'S WEIRD. HE'S NOT TALKING THAT MUCH.

DO YOU HAVE ANY SEEDS?

I'LL HAVE TO STOP AND GET SOME BIRDSEED.

SHOULD WE GET A CAGE FOR HIM?

SHE HAD TO LEAVE. HE HUNG OUT ON MY DESK FOR A WHILE, EATING SEEDS OFF SOME BREAD. HE SEEMED TO PERK UP FOR A MINUTE.

ORIGINAL ART

BUT THEN AN HOUR LATER I REALIZED HE WAS MISSING.

HEY, WHAT ARE YOU DOING DOWN THERE?

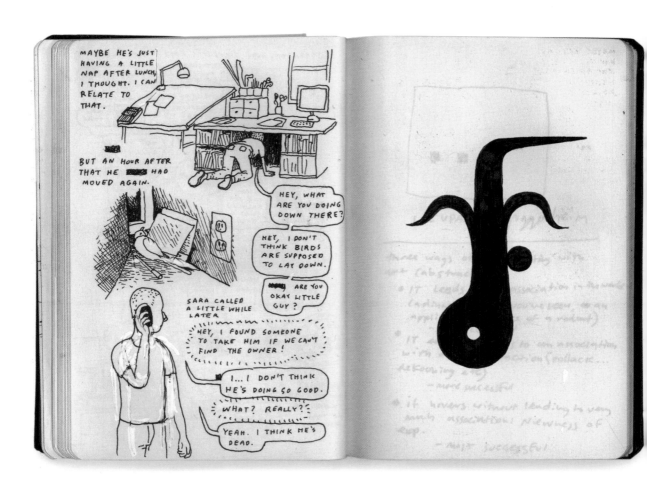

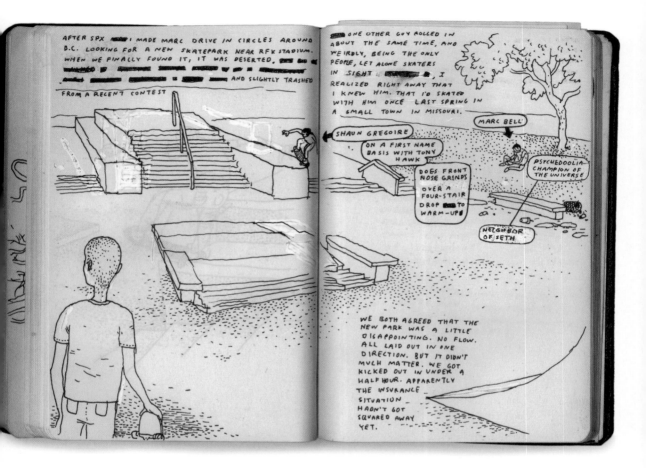

AFTER SPX ▓▓▓ I MADE MARC DRIVE IN CIRCLES AROUND
D.C. LOOKING FOR A NEW SKATEPARK NEAR RFK STADIUM.
WHEN WE FINALLY FOUND IT, IT WAS DESERTED. ▓▓▓ ▓▓ ▓▓
▓▓▓▓ ▓▓▓▓▓▓ ▓▓▓▓▓▓▓ ▓▓ ▓▓▓▓ AND SLIGHTLY TRASHED

FROM A RECENT CONTEST

▓▓▓ ONE OTHER GUY ROLLED IN
ABOUT THE SAME TIME, AND
WEIRDLY, BEING THE ONLY
PEOPLE, LET ALONE SKATERS
IN SIGHT ▓▓▓▓▓▓▓ ▓ , I
REALIZED RIGHT AWAY THAT
I KNEW HIM. THAT I'D SKATED
WITH HIM ONCE LAST SPRING IN
A SMALL TOWN IN MISSOURI.

MARC BELL

SHAUN GREGOIRE

ON A FIRST NAME
BASIS WITH TONY
HAWK

DOES FRONT
NOSE GRINDS
OVER A
FOUR-STAIR
DROP ▓▓▓ TO
WARM-UPS

PSYCHEDOOLIA-
CHAMPION OF
THE UNIVERSE

NEIGHBOR
OF SETH

WE BOTH AGREED THAT THE
NEW PARK WAS A LITTLE
DISAPPOINTING. NO FLOW.
ALL LAID OUT IN ONE
DIRECTION. BUT IT DIDN'T
MUCH MATTER. WE GOT
KICKED OUT IN UNDER A
HALF HOUR. APPARENTLY
THE INSURANCE
SITUATION _
HADN'T GOT
SQUARED AWAY
YET.

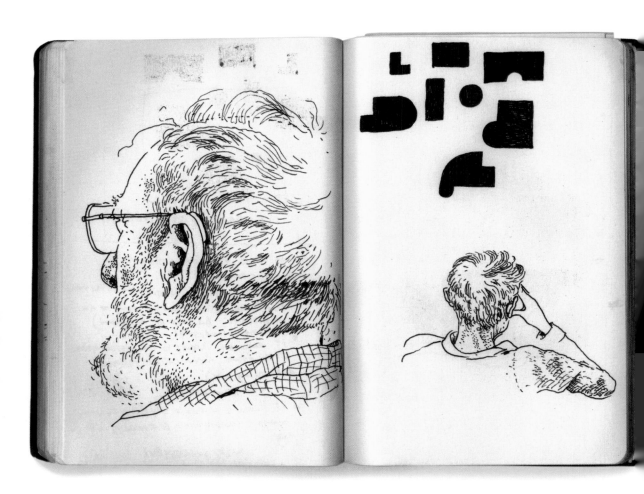

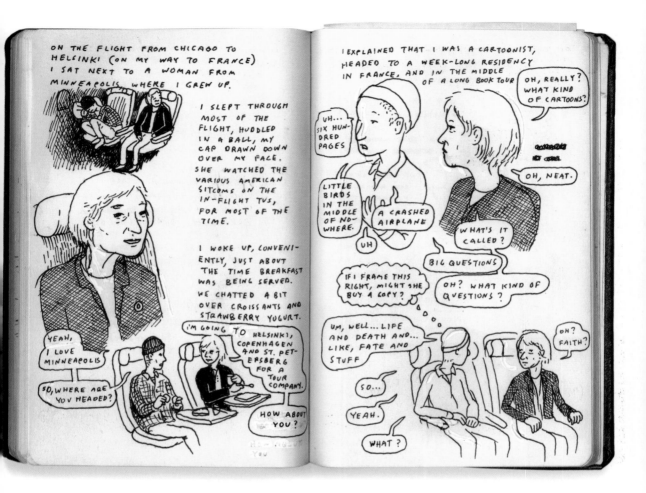

ON THE FLIGHT FROM CHICAGO TO HELSINKI (ON MY WAY TO FRANCE) I SAT NEXT TO A WOMAN FROM MINNEAPOLIS, WHERE I GREW UP.

I SLEPT THROUGH MOST OF THE FLIGHT, HUDDLED IN A BALL, MY CAP DRAWN DOWN OVER MY FACE. SHE WATCHED THE VARIOUS AMERICAN SITCOMS ON THE IN-FLIGHT TVS, FOR MOST OF THE TIME.

I WOKE UP, CONVENIENTLY, JUST ABOUT THE TIME BREAKFAST WAS BEING SERVED. WE CHATTED A BIT OVER CROISSANTS AND STRAWBERRY YOGURT.

YEAH, I LOVE MINNEAPOLIS

SO, WHERE ARE YOU HEADED?

I'M GOING TO HELSINKI, COPENHAGEN AND ST. PETERSBERG FOR A TOUR COMPANY.

HOW ABOUT YOU?

I EXPLAINED THAT I WAS A CARTOONIST, HEADED TO A WEEK-LONG RESIDENCY IN FRANCE, AND IN THE MIDDLE OF A LONG BOOK TOUR

OH, REALLY? WHAT KIND OF CARTOONS?

UH... SIX HUNDRED PAGES

OH, NEAT.

LITTLE BIRDS IN THE MIDDLE OF NOWHERE.

A CRASHED AIRPLANE

UH

WHAT'S IT CALLED?

BIG QUESTIONS

IF I FRAME THIS RIGHT, MIGHT SHE BUY A COPY?

OH? WHAT KIND OF QUESTIONS?

UM, WELL... LIFE AND DEATH AND... LIKE, FATE AND STUFF

OH? FAITH?

SO...

YEAH.

WHAT?

109

SHE HAD THIS PERFECT MINNESOTAN/MIDWESTERN
LOOK OF ░░░░ UTTER BLANKNESS, ░░░ ░░░░ BUT
ALSO OPENHEARTED, GENUINE INTEREST.

BUT THE CONVERSATION
STALLED. SO I LOOKED
OUT THE WINDOW
FOR ░░░░ ░░░░░░ ░░
░░░░░░░░░ A WHILE.

WE WERE ARRIVING IN
THE AIRSPACE OVER
FINLAND. THE
SKY WAS JUST
LIGHTENING WITH
THE FIRST LIGHT
OF MORNING.
A CRAZY
PATCHWORK
OF ISLANDS
BROKE UP
THE EVEN
EXPANSE
OF OCEAN
BELOW.
THE DISTANT
HORIZON WAS
SMUDGED
WITH PINK
AND ORANGE
WHERE THE
SUN WAS PREP-
ARING TO RISE.

WE CHATTED IDLY A BIT MORE ABOUT
TRAVEL IN SCANDINAVIA, ABOUT HOW
GREAT MINNEAPOLIS IS. ABOUT THE WEATHER.

THE CONVERSATION PAUSED AGAIN FOR A SECOND.
THEN SHE SPOKE AGAIN

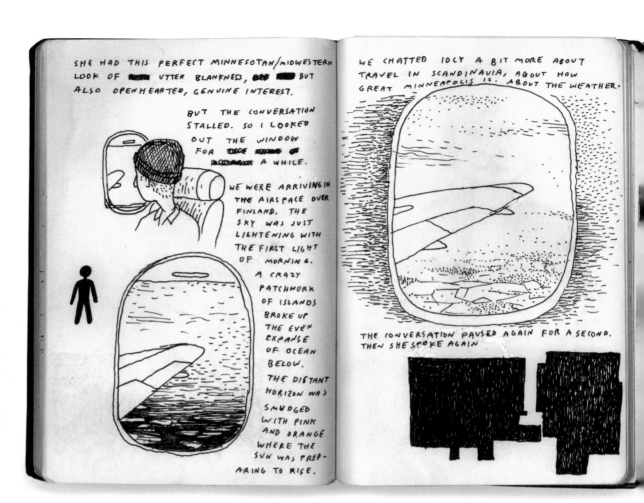

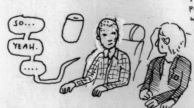

THESE IDEAS, WHICH SEEM SO ~~OBVIOUS~~ CLEAR AND SOLID TO ME IN MY OWN MIND OR IN CONVERSATION WITH OTHER WRITERS AND ARTISTS, SUDDENLY SEEM DETACHED AND INDISTINCT AS I DESCRIBE THEM TO MY SEATMATE.

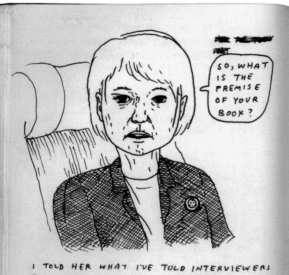

I TOLD HER WHAT I'VE TOLD INTERVIEWERS A HUNDRED TIMES, THAT IT'S ABOUT HOW WE FIND MEANING IN THE WORLD, ABOUT HOW WE ALL LOOK OUT AT THE SAME WORLD AND COME TO COMPLETELY DIFFERENT CONCLUSIONS ABOUT WHAT IT IS ~~AND~~ AND WHAT IT MEANS.

IT WAS LIKE PLAYING CATCH WITH SOMEONE WHO EITHER WASN'T CLEAR ON THE CONCEPT OR HADN'T DECIDED WHETHER TO PLAY YET.

OUTSIDE THE SUNRISE HAD FADED TO A PURPLISH HAZE. BODIES OF WATER WERE HIDDEN IN CLOUDS OF MIST. A GEOMETRIC QUILT OF ~~DULL~~ DULL GREENS AND BEIGES ALTERNATED WITH PATCHES OF PINE AND YELLOWING DECIDUOUS ~~FOREST~~ FOREST. I WAS AWARE OF MY TRAVELLING COMPANION WATCHING THE SCENE OVER MY SHOULDER.

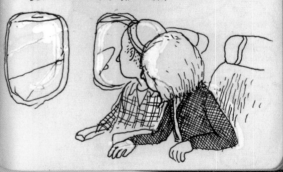

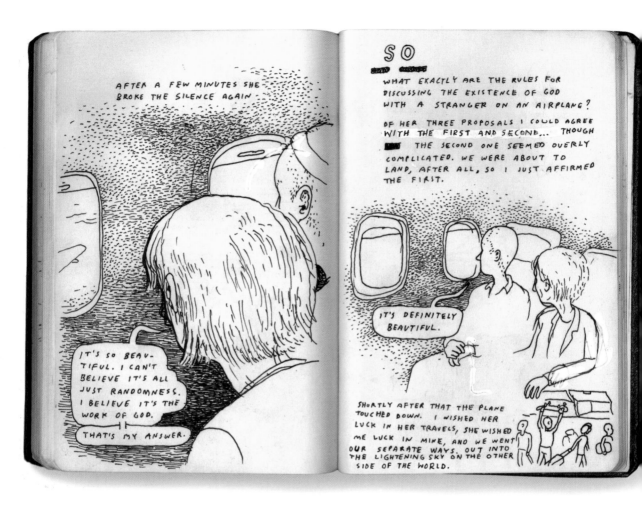

AFTER A FEW MINUTES SHE
BROKE THE SILENCE AGAIN.

IT'S SO BEAU-
TIFUL. I CAN'T
BELIEVE IT'S ALL
JUST RANDOMNESS.
I BELIEVE IT'S THE
WORK OF GOD.

THAT'S MY ANSWER.

SO

WHAT EXACTLY ARE THE RULES FOR
DISCUSSING THE EXISTENCE OF GOD
WITH A STRANGER ON AN AIRPLANE?

OF HER THREE PROPOSALS I COULD AGREE
WITH THE FIRST AND SECOND... THOUGH
THE SECOND ONE SEEMED OVERLY
COMPLICATED. WE WERE ABOUT TO
LAND, AFTER ALL, SO I JUST AFFIRMED
THE FIRST.

IT'S DEFINITELY
BEAUTIFUL.

SHORTLY AFTER THAT THE PLANE
TOUCHED DOWN. I WISHED HER
LUCK IN HER TRAVELS, SHE WISHED
ME LUCK IN MINE, AND WE WENT
OUR SEPARATE WAYS, OUT INTO
THE LIGHTENING SKY ON THE OTHER
SIDE OF THE WORLD.

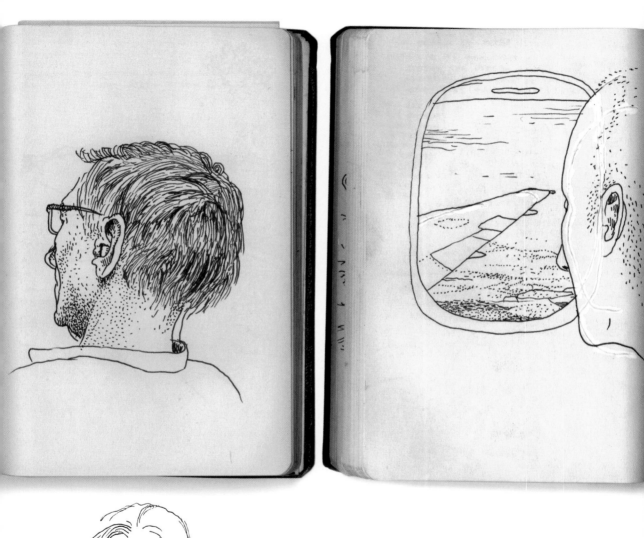

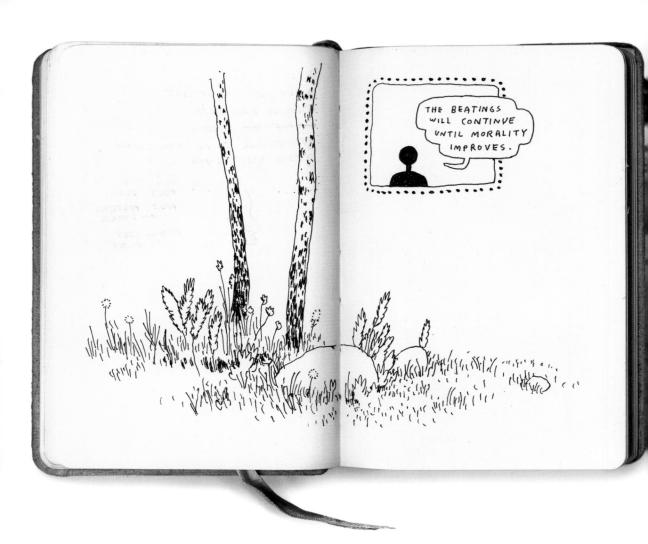

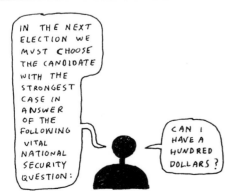

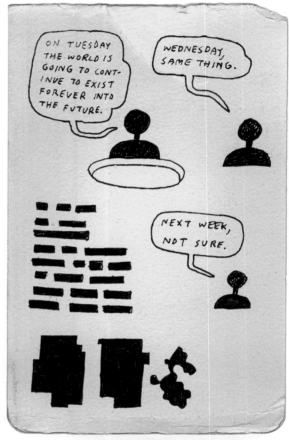

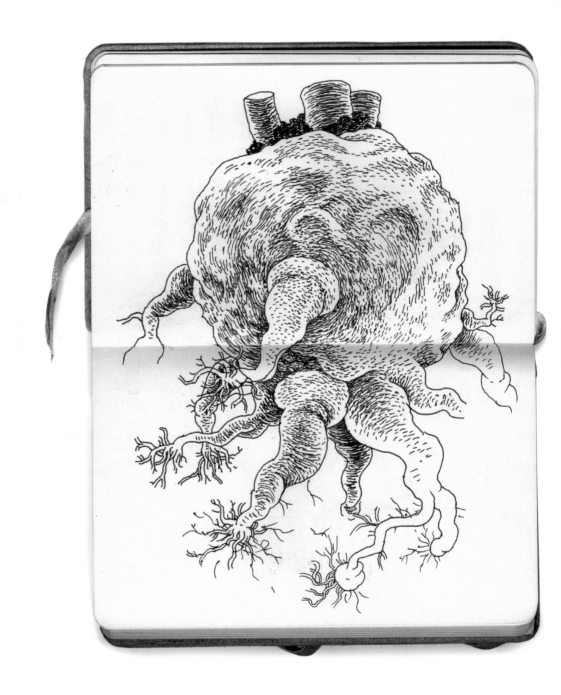

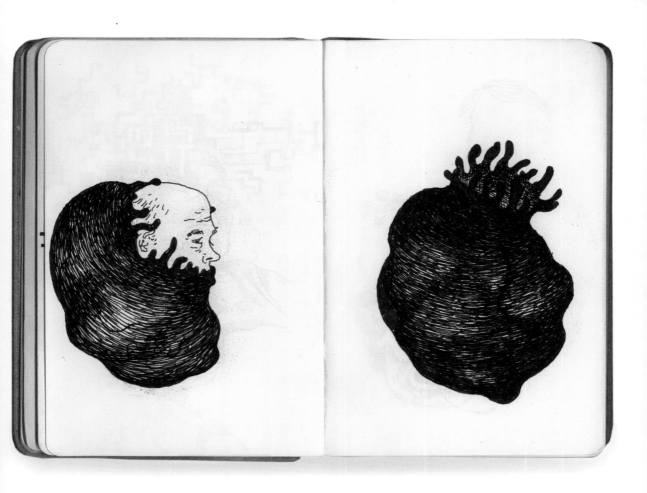

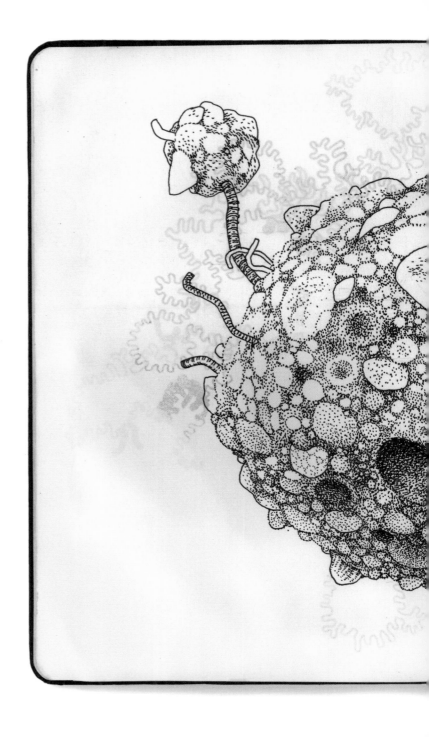

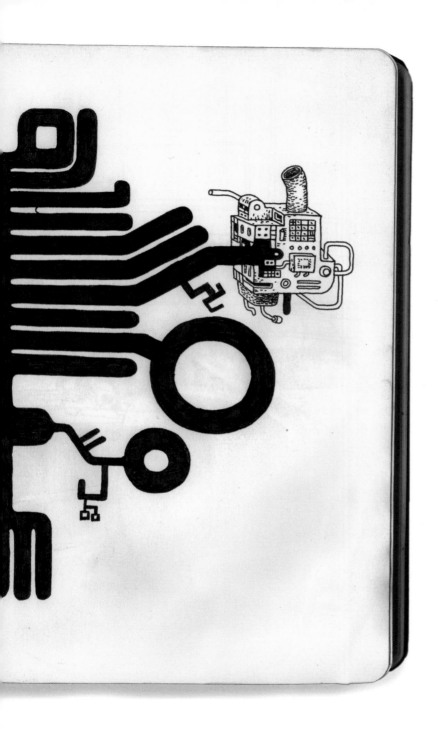

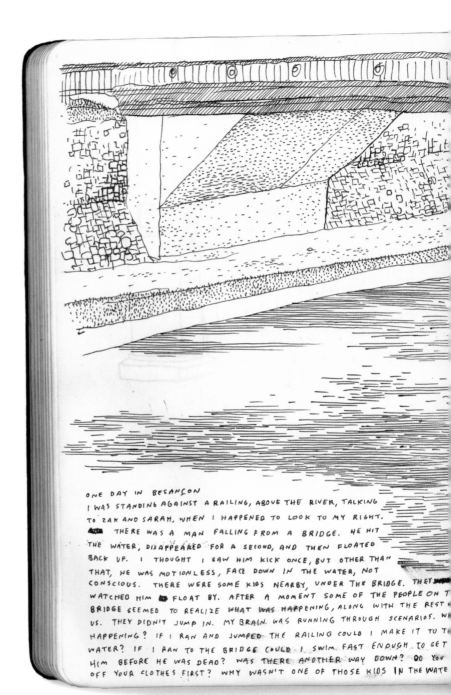

ONE DAY IN BESANÇON
I WAS STANDING AGAINST A RAILING, ABOVE THE RIVER, TALKING
TO ZAK AND SARAH, WHEN I HAPPENED TO LOOK TO MY RIGHT.
THERE WAS A MAN FALLING FROM A BRIDGE. HE HIT
THE WATER, DISAPPEARED FOR A SECOND, AND THEN FLOATED
BACK UP. I THOUGHT I SAW HIM KICK ONCE, BUT OTHER THAN
THAT, HE WAS MOTIONLESS, FACE DOWN IN THE WATER, NOT
CONSCIOUS. THERE WERE SOME KIDS NEARBY, UNDER THE BRIDGE. THEY
WATCHED HIM FLOAT BY. AFTER A MOMENT SOME OF THE PEOPLE ON T
BRIDGE SEEMED TO REALIZE WHAT WAS HAPPENING, ALONG WITH THE REST
US. THEY DIDN'T JUMP IN. MY BRAIN WAS RUNNING THROUGH SCENARIOS. W
HAPPENING? IF I RAN AND JUMPED THE RAILING COULD I MAKE IT TO T
WATER? IF I RAN TO THE BRIDGE COULD I SWIM FAST ENOUGH TO GET
HIM BEFORE HE WAS DEAD? WAS THERE ANOTHER WAY DOWN? DO YOU
OFF YOUR CLOTHES FIRST? WHY WASN'T ONE OF THOSE KIDS IN THE WATE

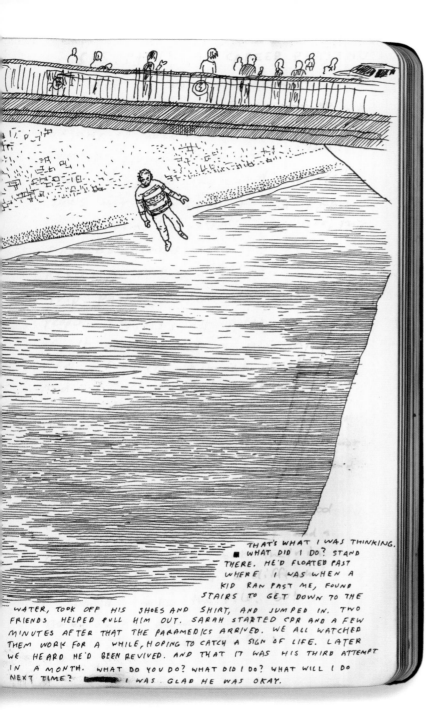

THAT'S WHAT I WAS THINKING. WHAT DID I DO? STAND THERE. HE'D FLOATED PAST WHERE I WAS WHEN A KID RAN PAST ME, FOUND STAIRS TO GET DOWN TO THE WATER, TOOK OFF HIS SHOES AND SHIRT, AND JUMPED IN. TWO FRIENDS HELPED PULL HIM OUT. SARAH STARTED CPR AND A FEW MINUTES AFTER THAT THE PARAMEDICS ARRIVED. WE ALL WATCHED THEM WORK FOR A WHILE, HOPING TO CATCH A SIGN OF LIFE. LATER WE HEARD HE'D BEEN REVIVED. AND THAT IT WAS HIS THIRD ATTEMPT IN A MONTH. WHAT DO YOU DO? WHAT DID I DO? WHAT WILL I DO NEXT TIME? ▬▬▬ I WAS. GLAD HE WAS OKAY.

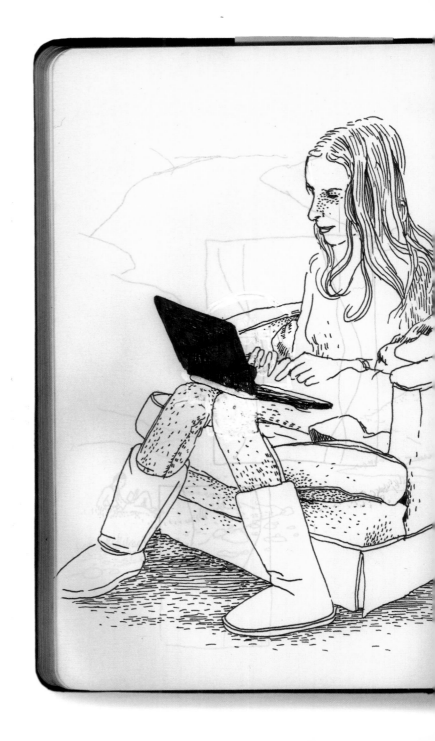

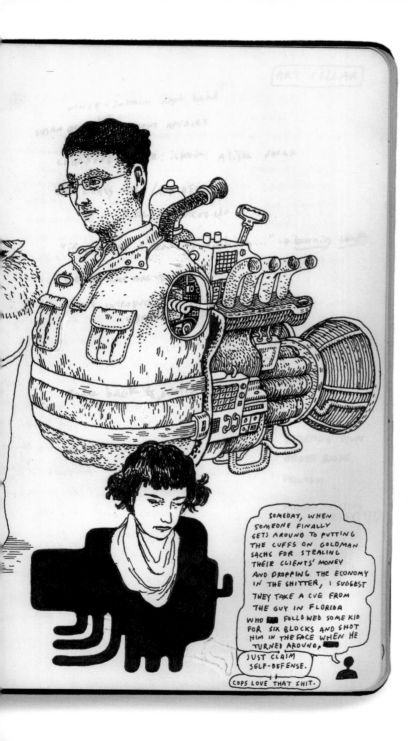

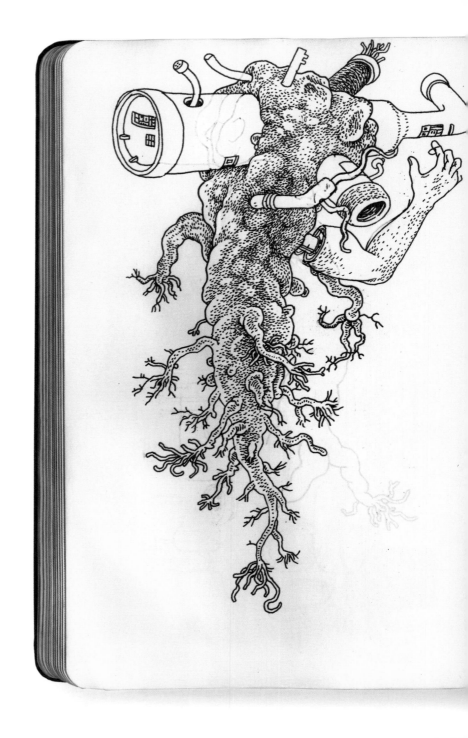

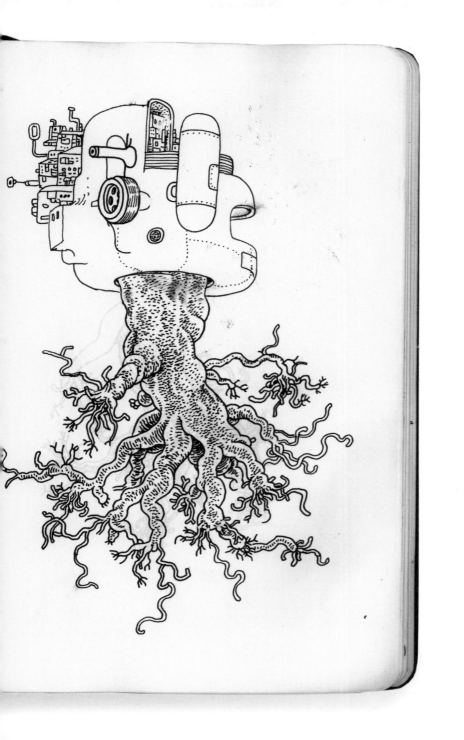

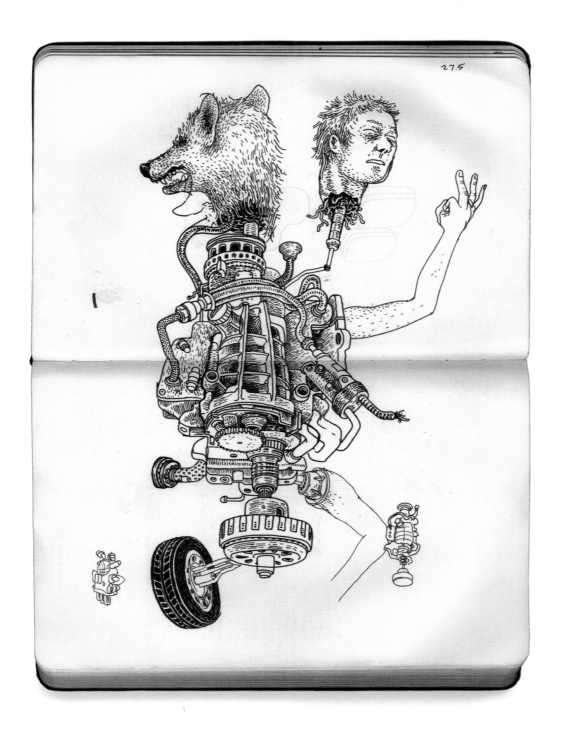

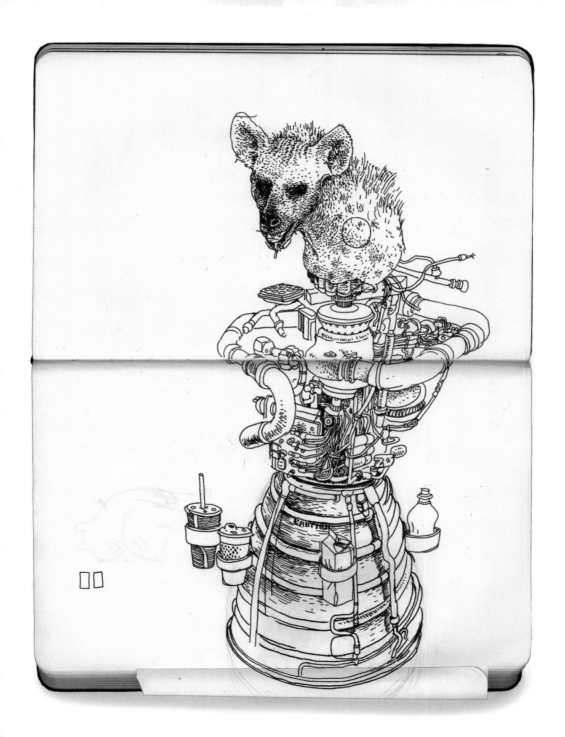

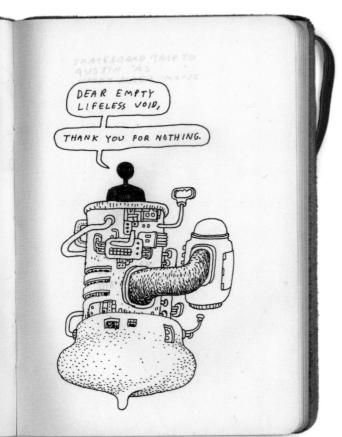

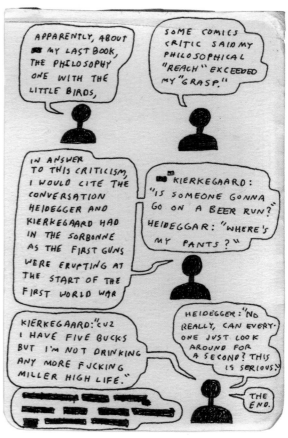

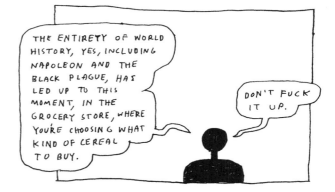

LATE NIGHT LIFE
ADVICE FROM SARA'S
DRUNK NEIGHBORS

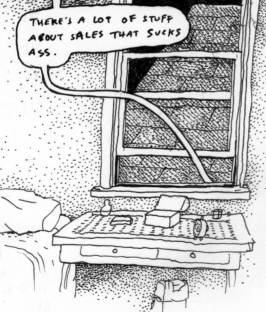

WE all GET CORRUPTED BY MTV AND FUCKIN'... ..WHAT WOMEN ARE SUPPOSED TO LOOK LIKE AND WHEN WE'RE SUPPOSED TO GET MARRIED AND STUFF.

THERE'S A LOT OF STUFF ABOUT SALES THAT SUCKS ASS.

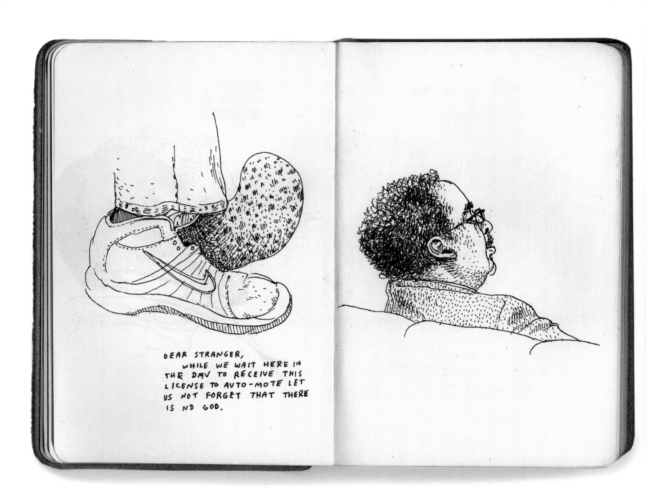

DEAR STRANGER,
 WHILE WE WAIT HERE IN
THE DMV TO RECEIVE THIS
LICENSE TO AUTO-MOTE LET
US NOT FORGET THAT THERE
IS NO GOD.

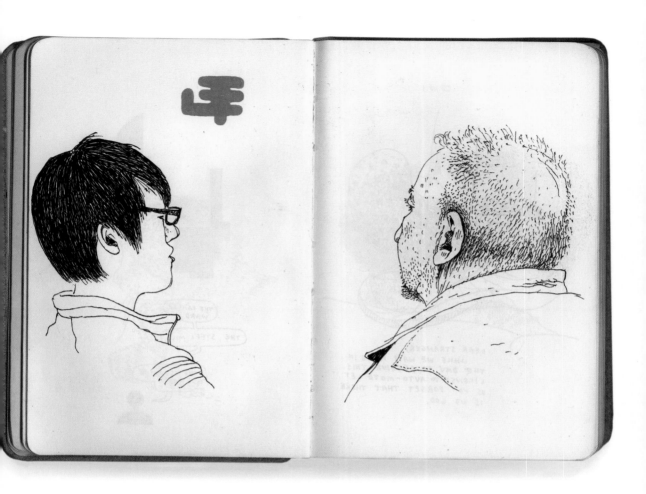

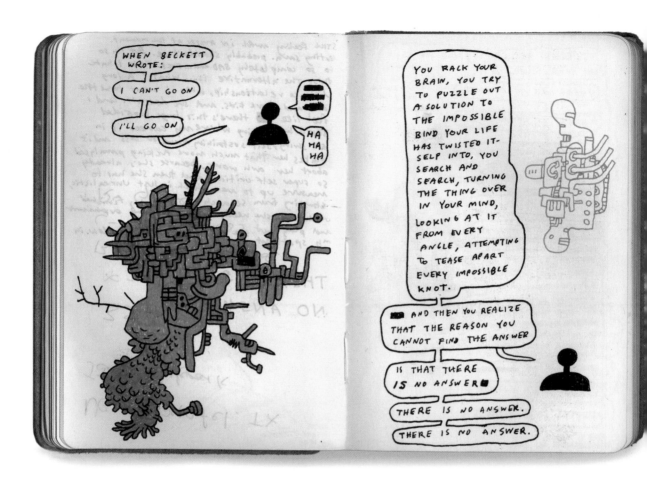

WHEN BECKETT WROTE:

I CAN'T GO ON

I'LL GO ON

HA HA HA

YOU RACK YOUR BRAIN, YOU TRY TO PUZZLE OUT A SOLUTION TO THE IMPOSSIBLE BIND YOUR LIFE HAS TWISTED IT-SELF INTO, YOU SEARCH AND SEARCH, TURNING THE THING OVER IN YOUR MIND, LOOKING AT IT FROM EVERY ANGLE, ATTEMPTING TO TEASE APART EVERY IMPOSSIBLE KNOT.

AND THEN YOU REALIZE THAT THE REASON YOU CANNOT FIND THE ANSWER

IS THAT THERE IS NO ANSWER

THERE IS NO ANSWER.

THERE IS NO ANSWER.

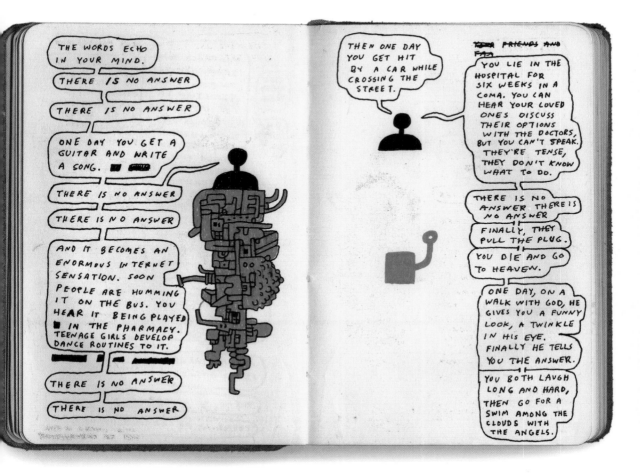

THE WORDS ECHO IN YOUR MIND.

THERE IS NO ANSWER

THERE IS NO ANSWER

ONE DAY YOU GET A GUITAR AND WRITE A SONG. ▪️ ▬▬

THERE IS NO ANSWER

THERE IS NO ANSWER

AND IT BECOMES AN ENORMOUS INTERNET SENSATION. SOON PEOPLE ARE HUMMING IT ON THE BUS. YOU HEAR IT BEING PLAYED ▪️ IN THE PHARMACY. TEENAGE GIRLS DEVELOP DANCE ROUTINES TO IT.

THERE IS NO ANSWER

THERE IS NO ANSWER

THEN ONE DAY YOU GET HIT BY A CAR WHILE CROSSING THE STREET.

~~YOUR~~ FRIENDS AND ~~FAM~~

YOU LIE IN THE HOSPITAL FOR SIX WEEKS IN A COMA. YOU CAN HEAR YOUR LOVED ONES DISCUSS THEIR OPTIONS WITH THE DOCTORS, BUT YOU CAN'T SPEAK. THEY'RE TENSE, THEY DON'T KNOW WHAT TO DO.

THERE IS NO ANSWER THERE IS NO ANSWER

FINALLY, THEY PULL THE PLUG.

YOU DIE AND GO TO HEAVEN.

ONE DAY, ON A WALK WITH GOD, HE GIVES YOU A FUNNY LOOK, A TWINKLE IN HIS EYE. FINALLY HE TELLS YOU THE ANSWER.

YOU BOTH LAUGH LONG AND HARD, THEN GO FOR A SWIM AMONG THE CLOUDS WITH THE ANGELS.

133

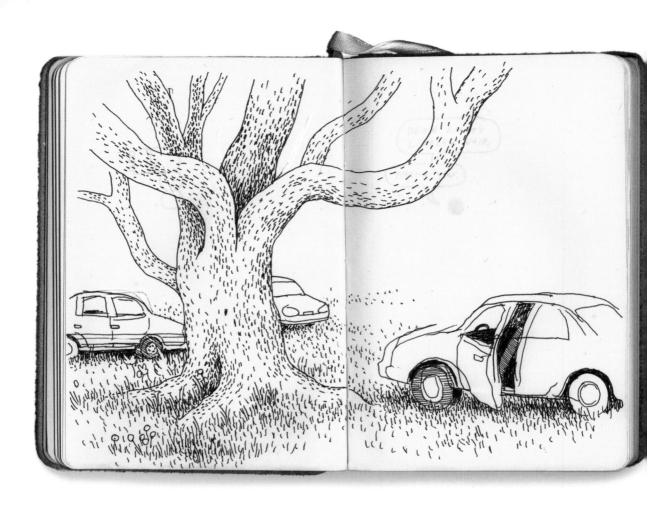

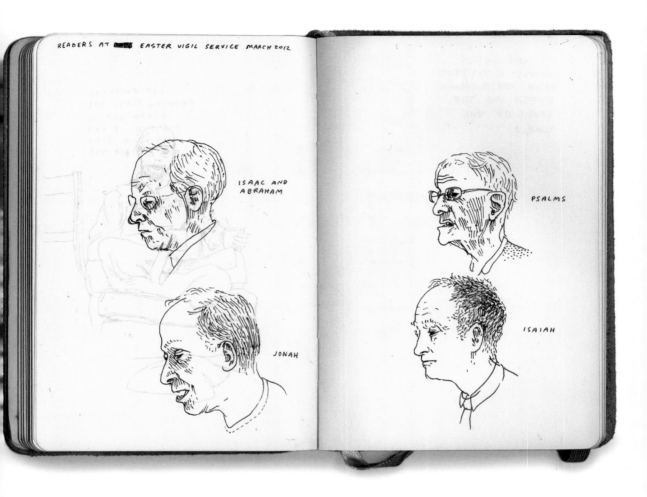

READERS AT ~~CHURCH~~ EASTER VIGIL SERVICE MARCH 2012

ISAAC AND
ABRAHAM

PSALMS

JONAH

ISAIAH

135

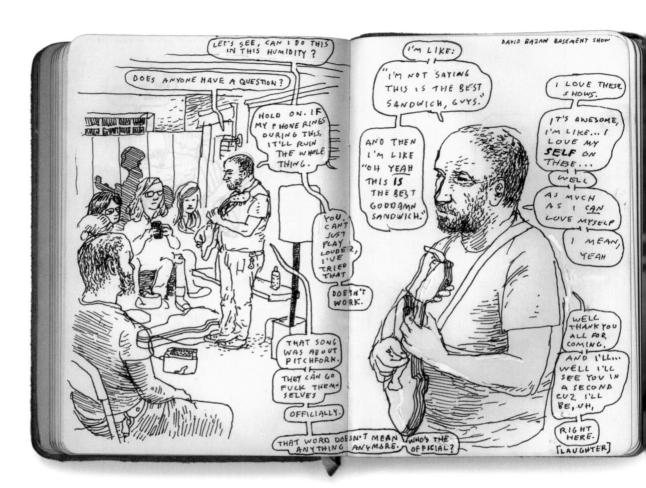

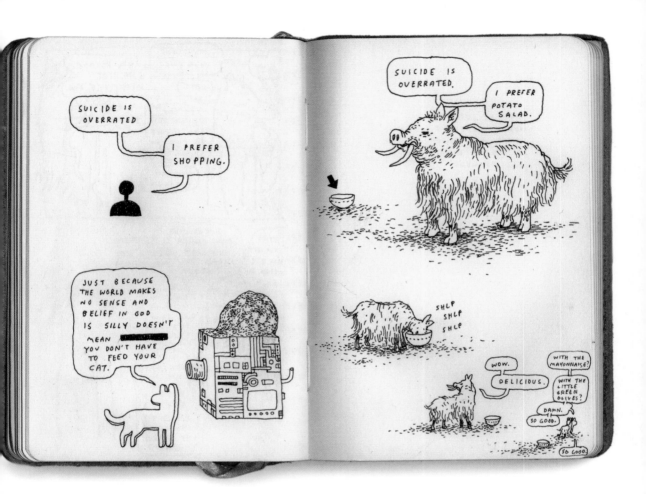

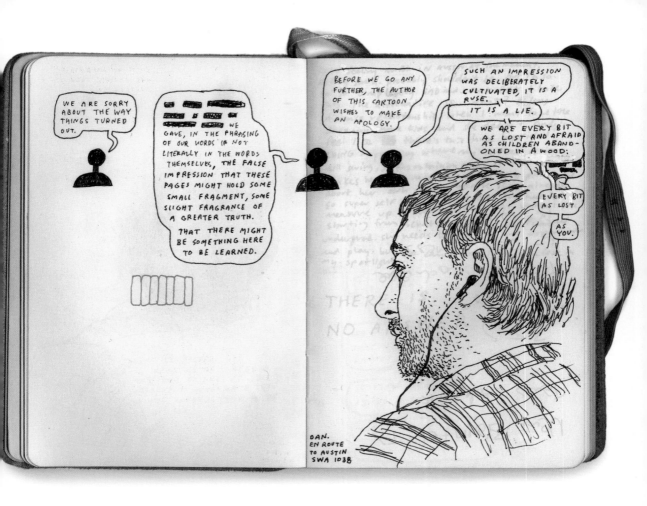

WE ARE SORRY ABOUT THE WAY THINGS TURNED OUT.

WE GAVE, IN THE PHRASING OF OUR WORDS IF NOT LITERALLY IN THE WORDS THEMSELVES, THE FALSE IMPRESSION THAT THESE PAGES MIGHT HOLD SOME SMALL FRAGMENT, SOME SLIGHT FRAGRANCE OF A GREATER TRUTH.

THAT THERE MIGHT BE SOMETHING HERE TO BE LEARNED.

BEFORE WE GO ANY FURTHER, THE AUTHOR OF THIS CARTOON WISHES TO MAKE AN APOLOGY.

SUCH AN IMPRESSION WAS DELIBERATELY CULTIVATED, IT IS A RUSE.

IT IS A LIE.

WE ARE EVERY BIT AS LOST AND AFRAID AS CHILDREN ABANDONED IN A WOOD:

EVERY BIT AS LOST

AS YOU.

DAN.
EN ROUTE TO AUSTIN
SWA 103B

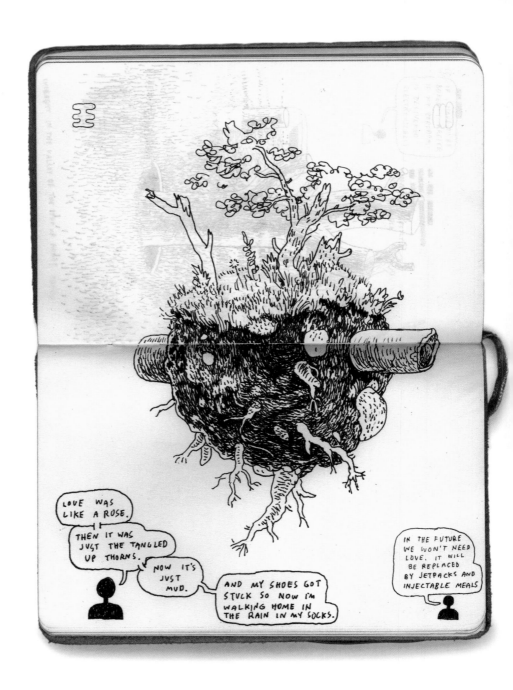

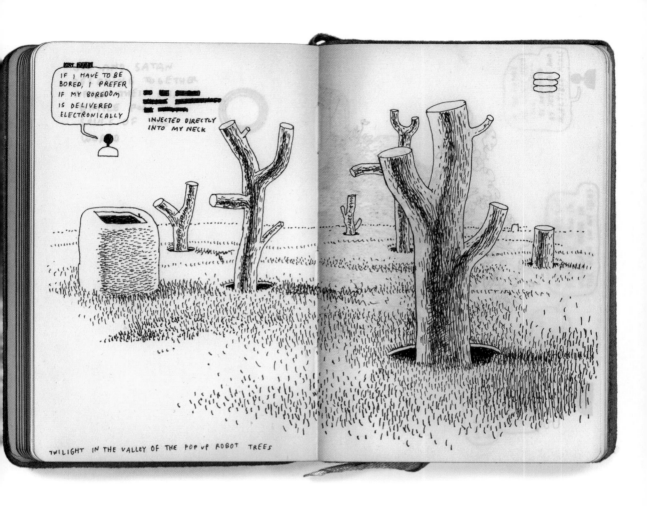

TWILIGHT IN THE VALLEY OF THE POP UP ROBOT TREES

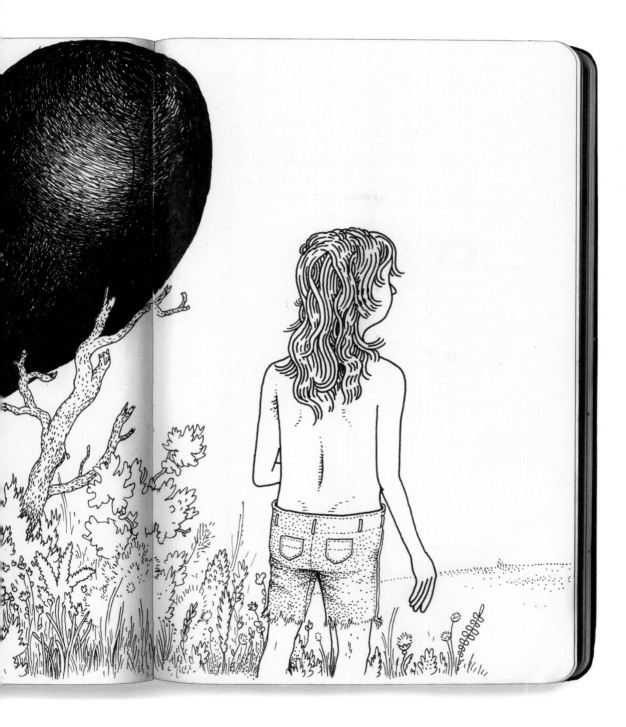

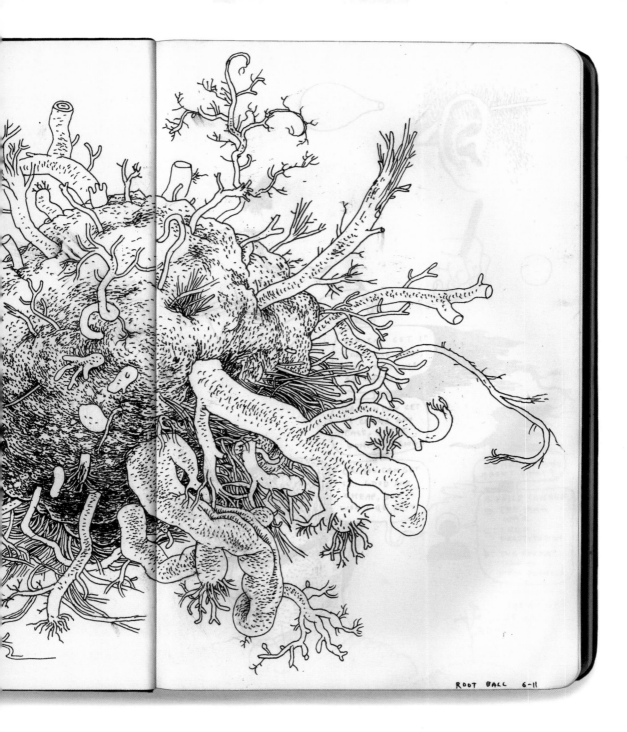

ROOT BALL 6-11

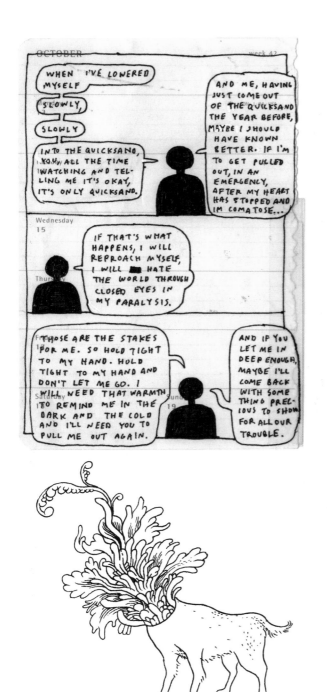

WHEN I'VE LOWERED MYSELF SLOWLY, SLOWLY INTO THE QUICKSAND, YOU ALL THE TIME WATCHING AND TELLING ME IT'S OKAY, IT'S ONLY QUICKSAND.

AND ME, HAVING JUST COME OUT OF THE QUICKSAND THE YEAR BEFORE, MAYBE I SHOULD HAVE KNOWN BETTER. IF I'M TO GET PULLED OUT, IN AN EMERGENCY, AFTER MY HEART HAS STOPPED AND IM COMATOSE...

Wednesday
15

IF THAT'S WHAT HAPPENS, I WILL REPROACH MYSELF, I WILL HATE THE WORLD THROUGH CLOSED EYES IN MY PARALYSIS.

Thursday

THOSE ARE THE STAKES FOR ME. SO HOLD TIGHT TO MY HAND. HOLD TIGHT TO MY HAND AND DON'T LET ME GO. I WILL NEED THAT WARMTH TO REMIND ME IN THE DARK AND THE COLD AND I'LL NEED YOU TO PULL ME OUT AGAIN.

AND IF YOU LET ME IN DEEP ENOUGH, MAYBE I'LL COME BACK WITH SOME THING PRECIOUS TO SHOW FOR ALL OUR TROUBLE.

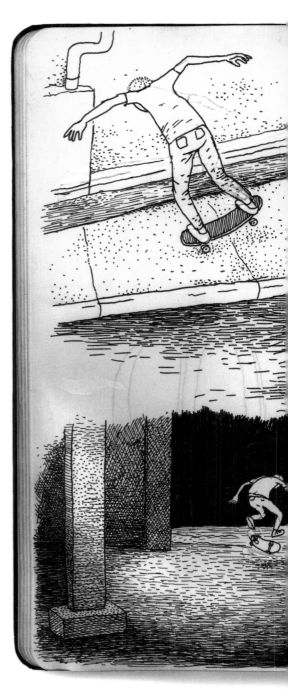

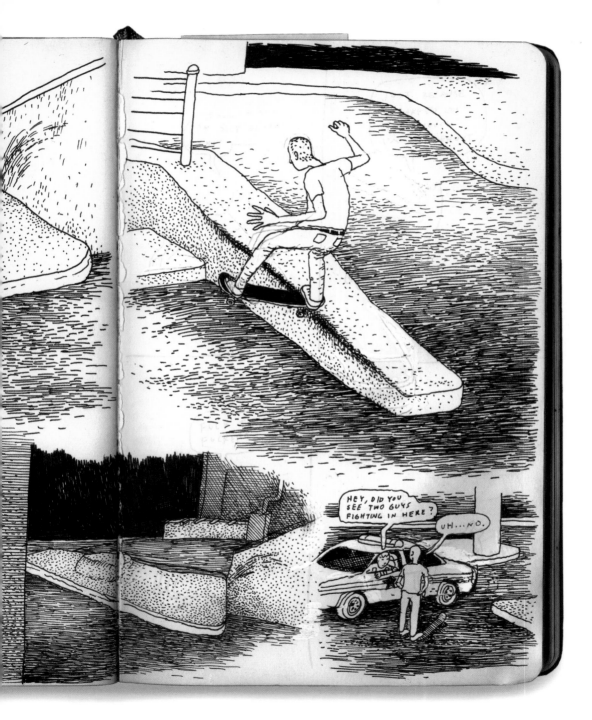

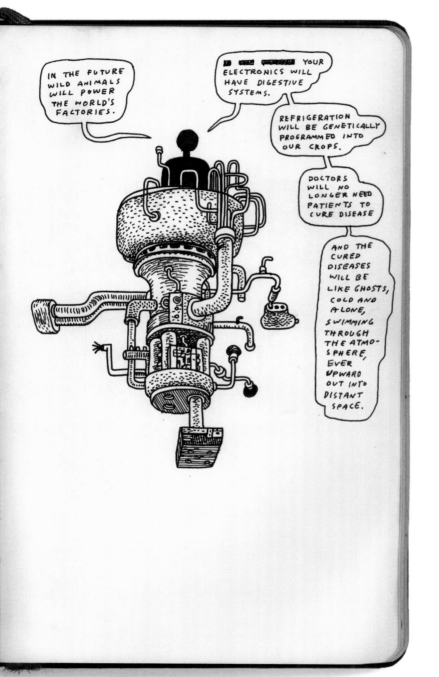

MAN TALKING
ON FUTURISTIC
COMMUNICATION
DEVICE.

BIG STAR, CHICAGO
3-2013

Franziskaner
WEISSBIER

WILL SMASH
YOUR IPHONE
WITH A
HAMMER
FOR $5

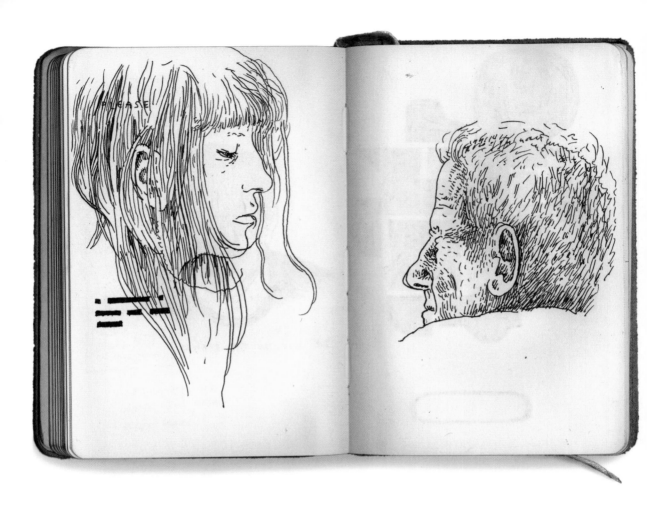

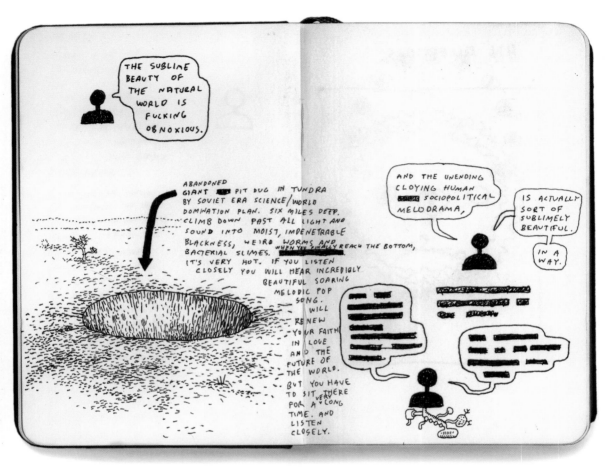

THE SUBLIME BEAUTY OF THE NATURAL WORLD IS FUCKING OBNOXIOUS.

ABANDONED GIANT ▪▪ PIT DUG IN TUNDRA BY SOVIET ERA SCIENCE/WORLD DOMINATION PLAN. SIX MILES DEEP. CLIMB DOWN PAST ALL LIGHT AND SOUND INTO MOIST, IMPENETRABLE BLACKNESS, WEIRD WORMS AND BACTERIAL SLIMES. WHEN YOU FINALLY REACH THE BOTTOM, IT'S VERY HOT. IF YOU LISTEN CLOSELY YOU WILL HEAR INCREDIBLY BEAUTIFUL SOARING MELODIC POP SONG. WILL RENEW YOUR FAITH IN LOVE AND THE FUTURE OF THE WORLD. BUT YOU HAVE TO SIT THERE FOR A VERY LONG TIME. AND LISTEN CLOSELY.

AND THE UNENDING CLOYING HUMAN ▪▪ SOCIOPOLITICAL MELODRAMA,

IS ACTUALLY SORT OF SUBLIMELY BEAUTIFUL.

IN A WAY.

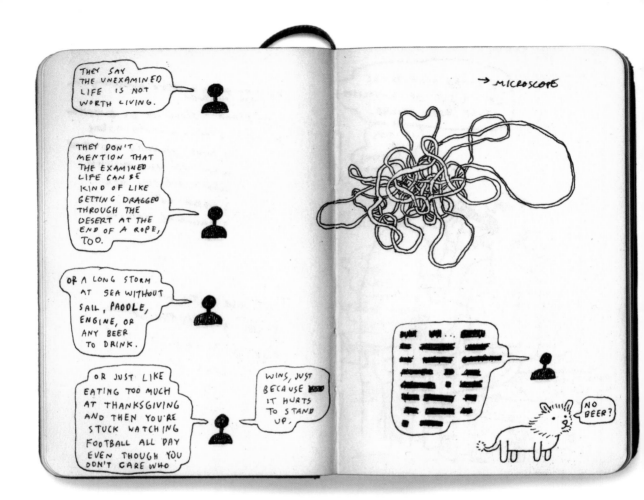

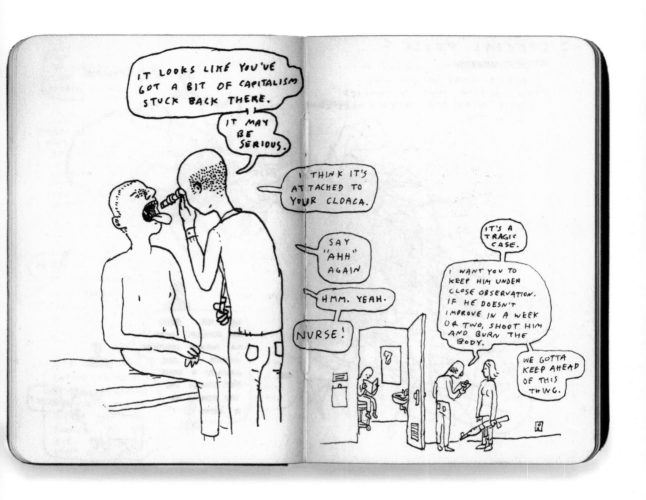

155

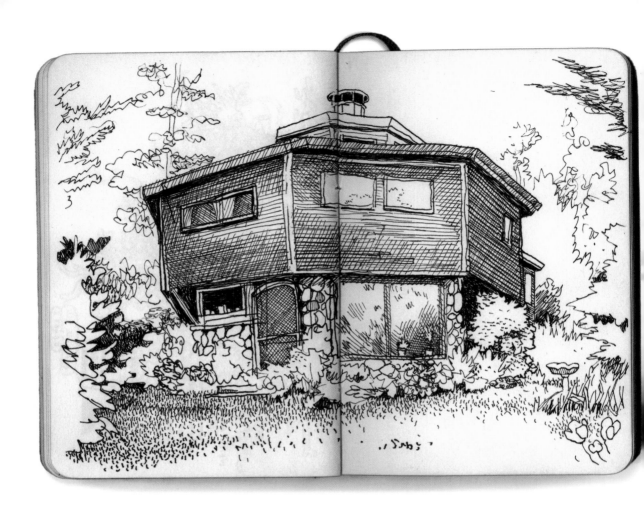

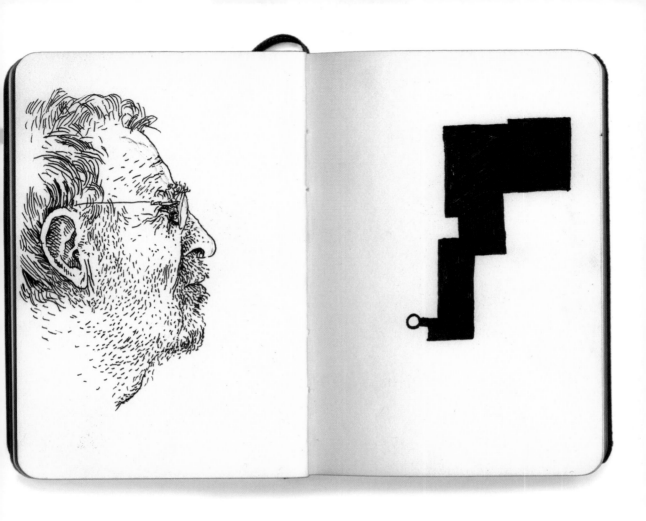

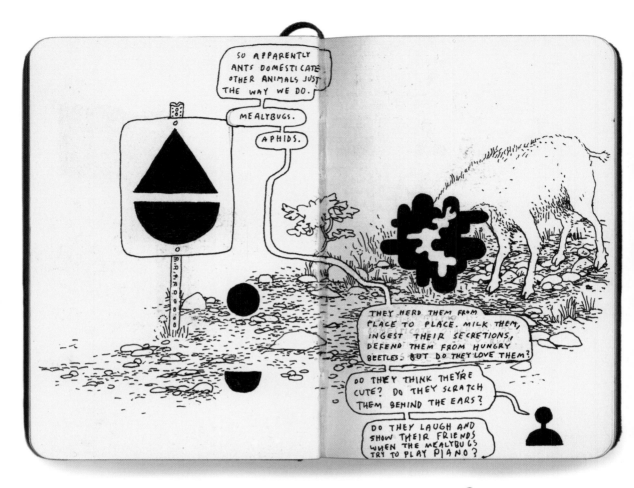

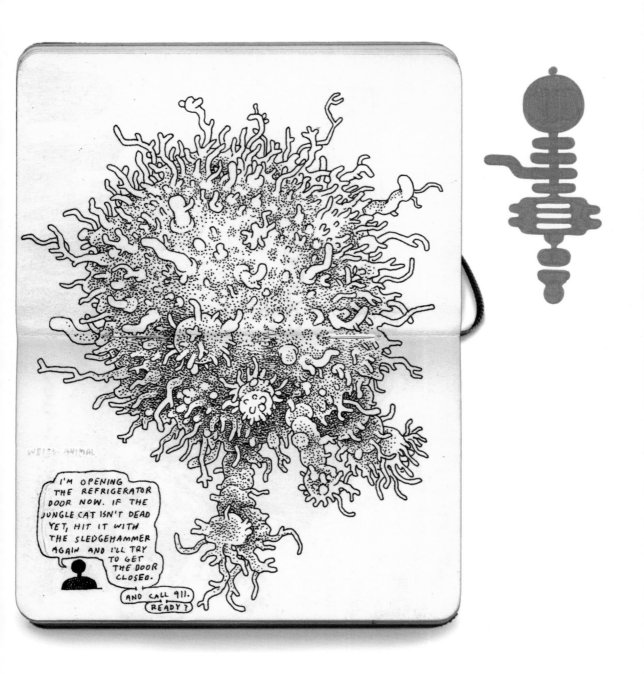

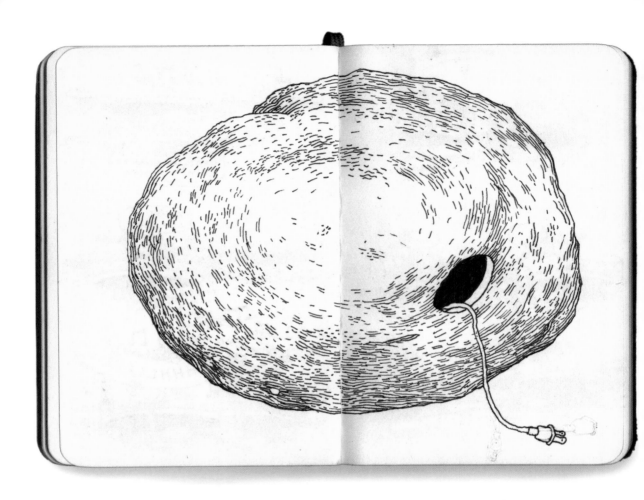

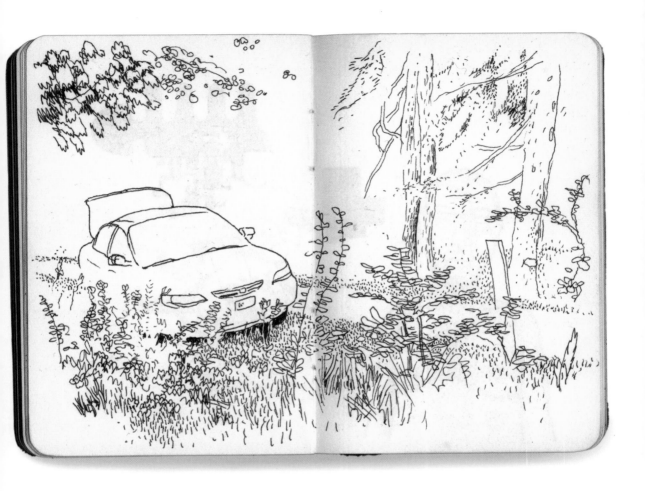

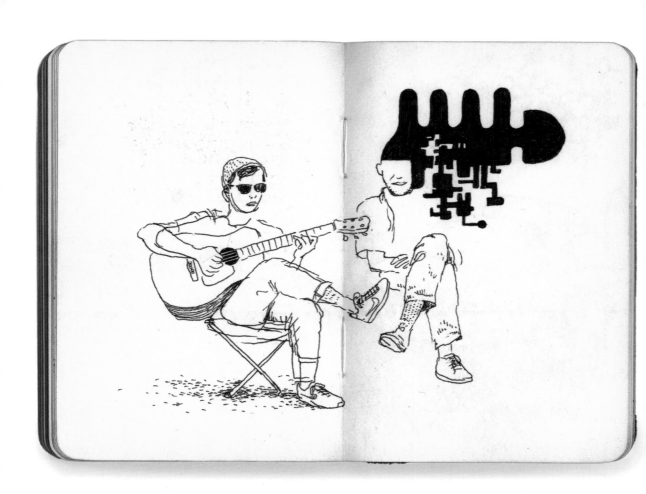

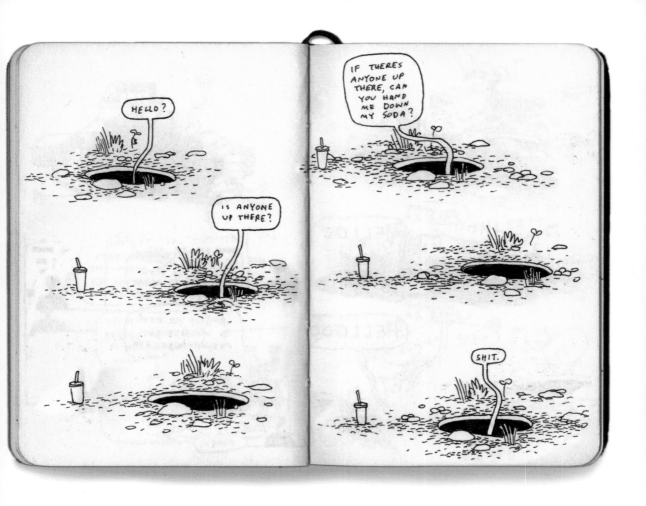

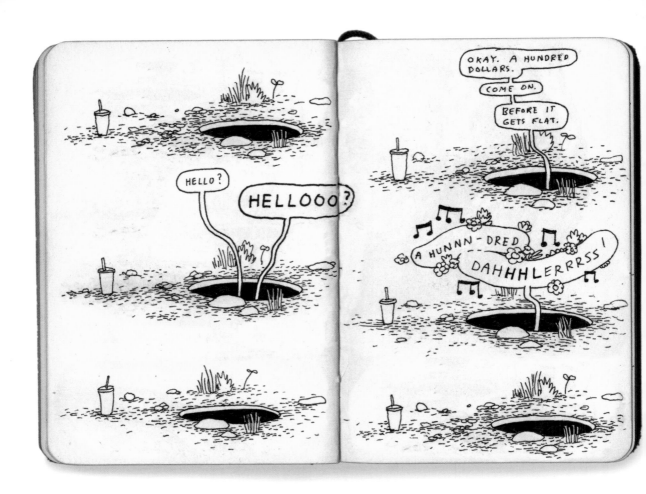

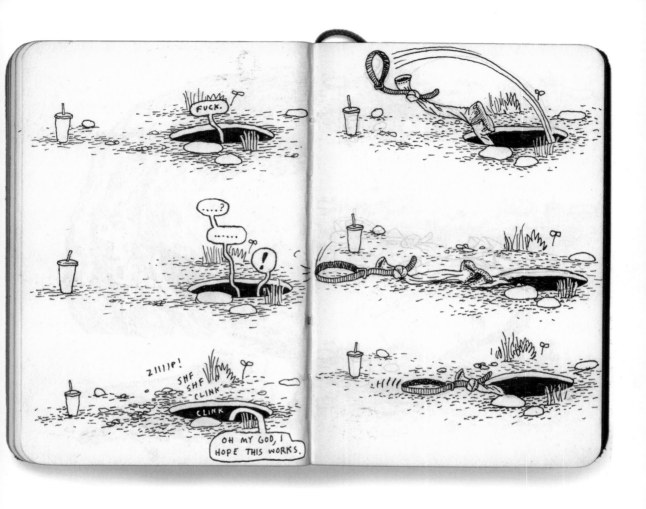

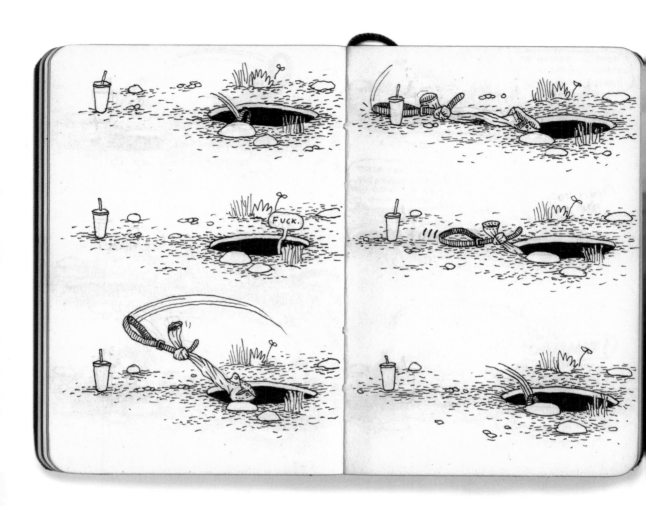

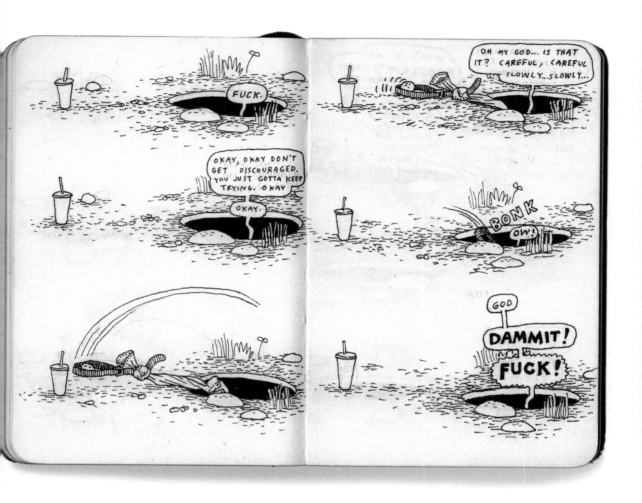

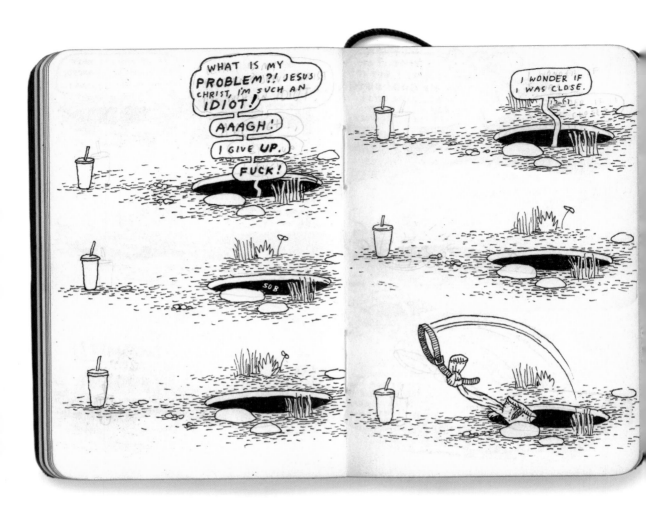

168

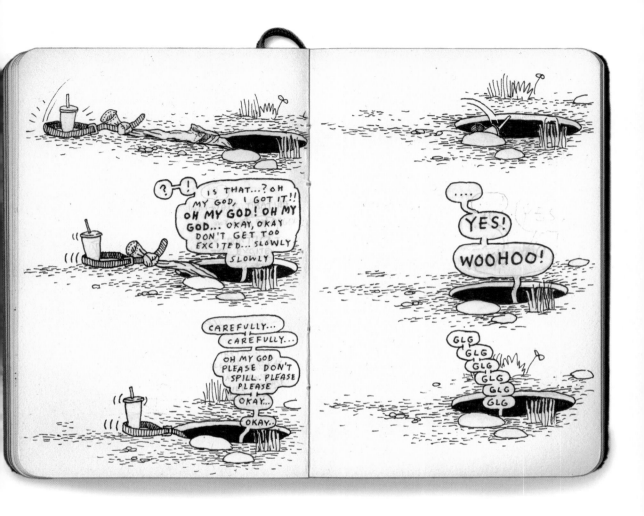

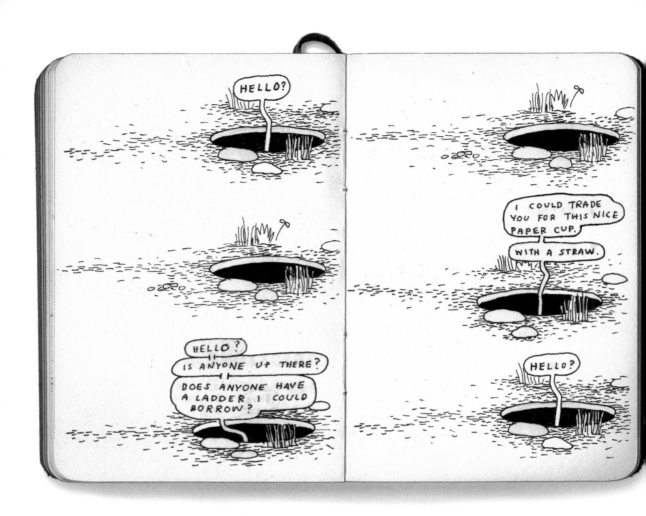

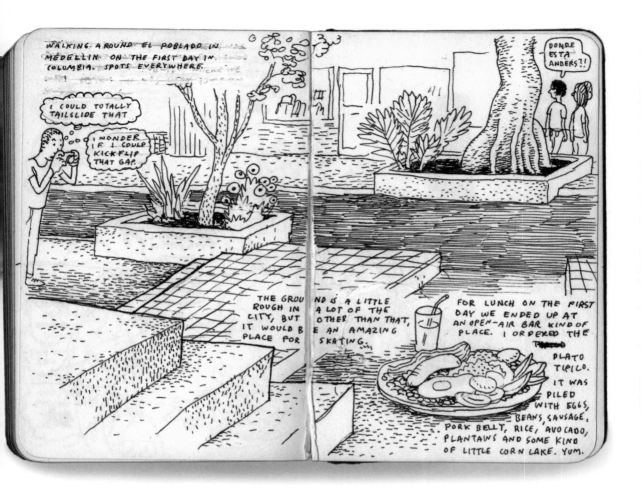

WALKING AROUND EL POBLADO IN MEDELLIN ON THE FIRST DAY IN COLUMBIA. SPOTS EVERYWHERE.

I COULD TOTALLY TAILSLIDE THAT

I WONDER IF I COULD KICKFLIP THAT GAP.

DONDE ESTA ANDERS?!

THE GROUND IS A LITTLE ROUGH IN A LOT OF THE CITY, BUT OTHER THAN THAT, IT WOULD BE AN AMAZING PLACE FOR SKATING.

FOR LUNCH ON THE FIRST DAY WE ENDED UP AT AN OPEN-AIR BAR KIND OF PLACE. I ORDERED THE PLATO TIPICO. IT WAS PILED WITH EGGS, BEANS, SAUSAGE, PORK BELLY, RICE, AVOCADO, PLANTAINS AND SOME KIND OF LITTLE CORN CAKE. YUM.

171

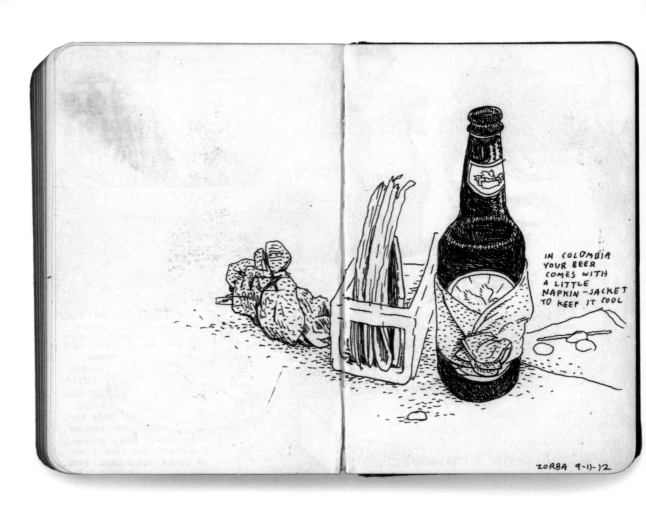

IN COLOMBIA
YOUR BEER
COMES WITH
A LITTLE
NAPKIN-JACKET
TO KEEP IT COOL

ZORBA 9-1-12

172

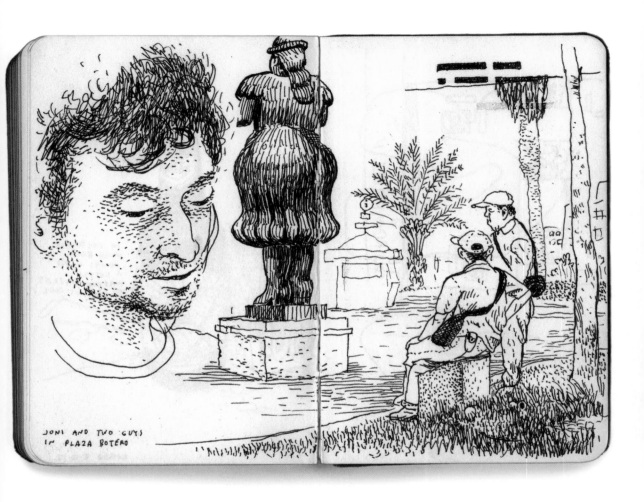

JONI AND TWO GUYS
IN PLAZA BOTERO

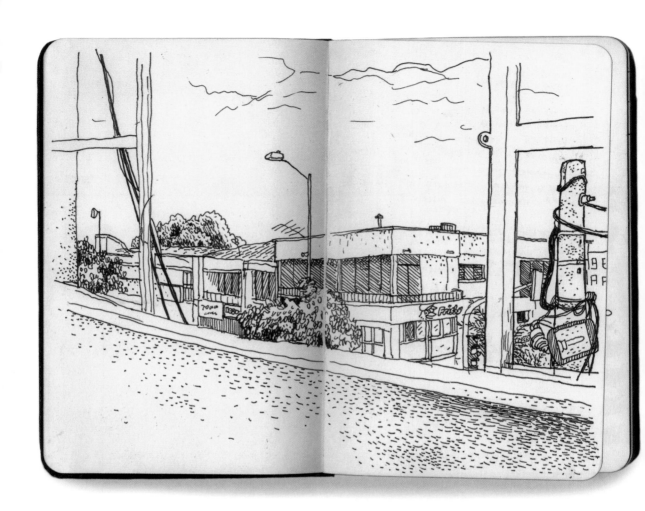

174

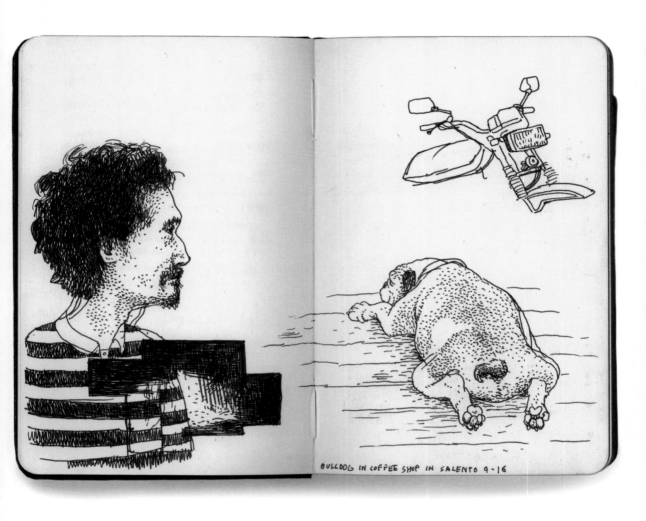

BULLDOG IN COFFEE SHOP IN SALENTO 9-16

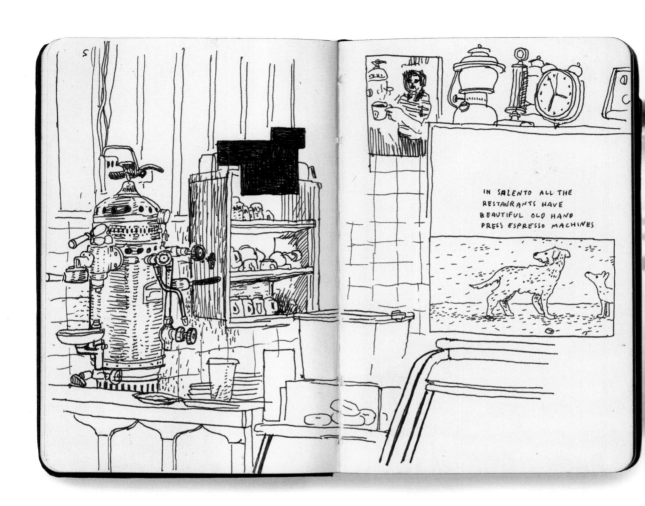

IN SALENTO ALL THE
RESTAURANTS HAVE
BEAUTIFUL OLD HAND
PRESS ESPRESSO MACHINES

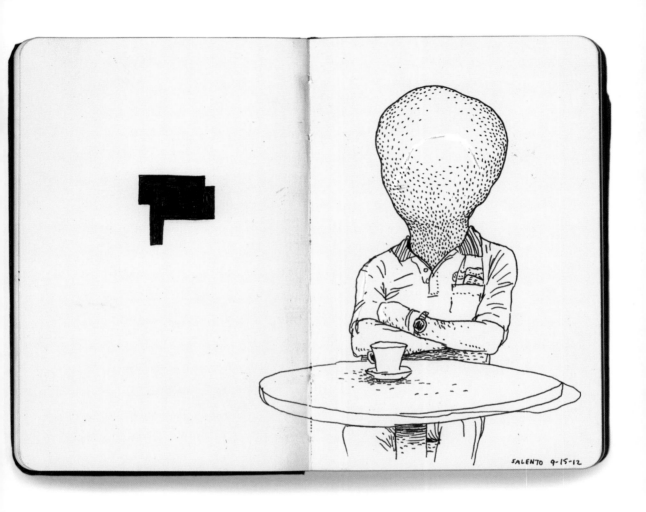

SALENTO 9-15-12

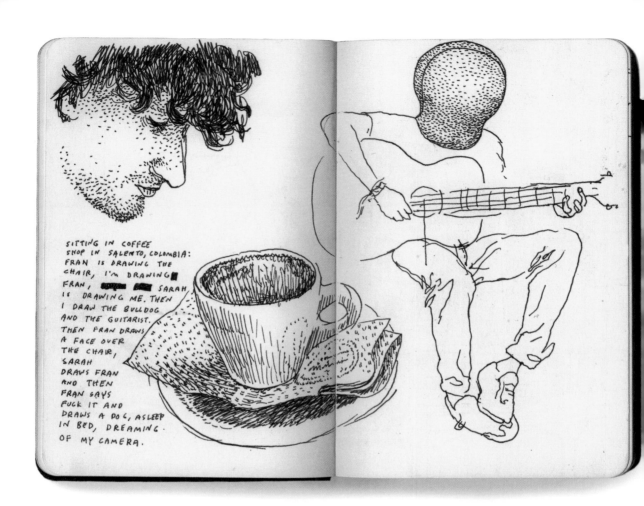

SITTING IN COFFEE
SHOP IN SALENTO, COLOMBIA:
FRAN IS DRAWING THE
CHAIR, I'M DRAWING
FRAN, ▮▮▮▮ ▮▮ SARAH
IS DRAWING ME. THEN
I DRAW THE BULLDOG
AND THE GUITARIST.
THEN FRAN DRAWS
A FACE OVER
THE CHAIR,
SARAH
DRAWS FRAN
AND THEN
FRAN SAYS
FUCK IT AND
DRAWS A DOG, ASLEEP
IN BED, DREAMING
OF MY CAMERA.

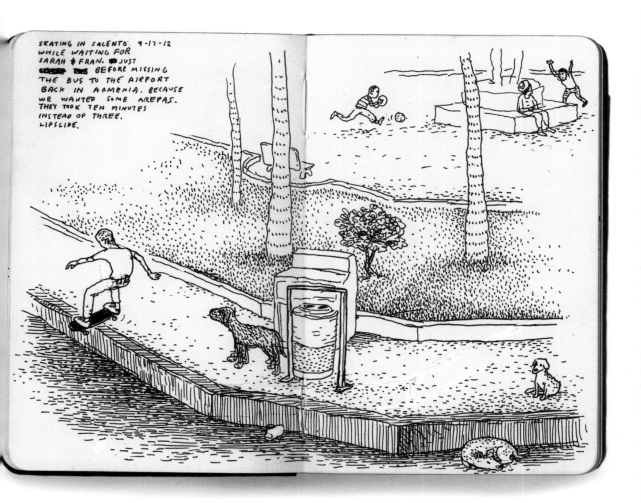

SKATING IN SALENTO 9-17-12
WHILE WAITING FOR
SARAH & FRAN. ~~BUS~~ JUST
~~SKATED~~ ~~BUS~~ BEFORE MISSING
THE BUS TO THE AIRPORT
BACK IN ARMENIA. BECAUSE
WE WANTED SOME AREPAS.
THEY TOOK TEN MINUTES
INSTEAD OF THREE.
LIPSLIDE.

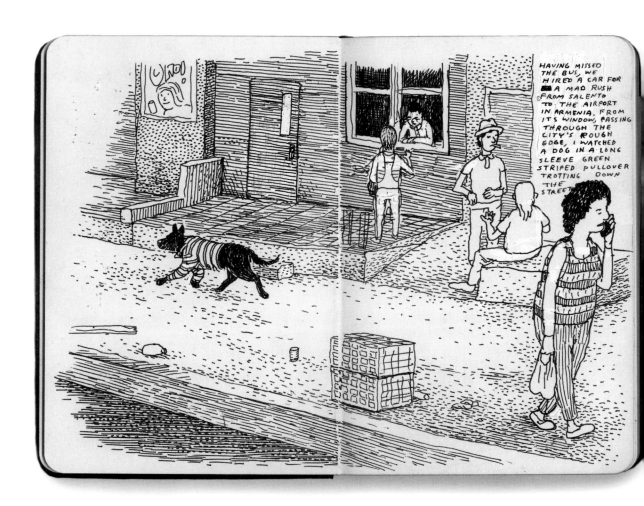

HAVING MISSED THE BUS, WE HIRED A CAR FOR A MAD RUSH FROM SALENTO TO THE AIRPORT IN ARMENIA, FROM ITS WINDOW, PASSING THROUGH THE CITY'S ROUGH EDGE, I WATCHED A DOG IN A LONG SLEEVE GREEN STRIPED PULLOVER TROTTING DOWN THE STREET.

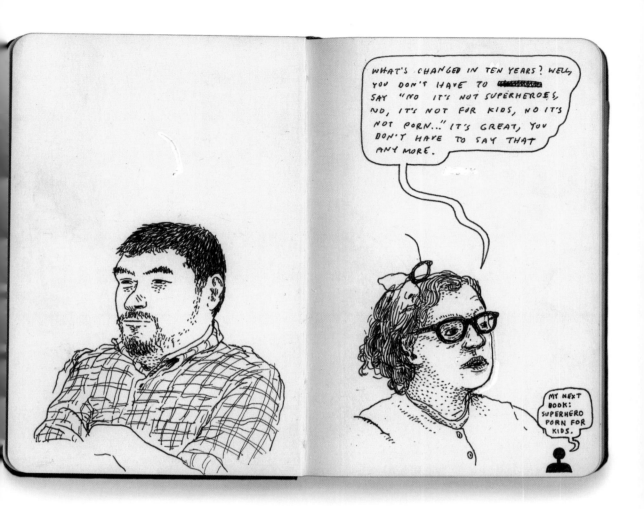

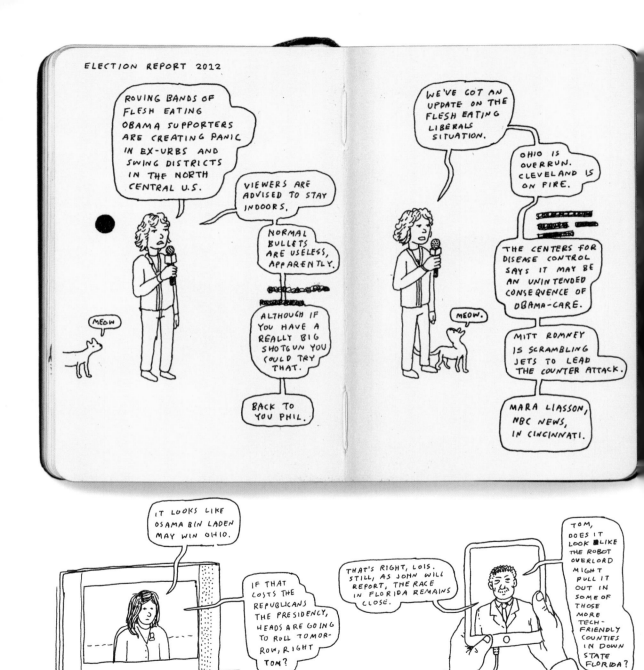

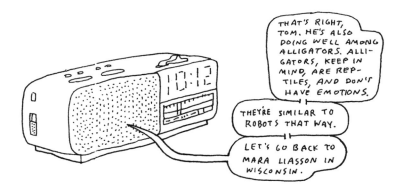

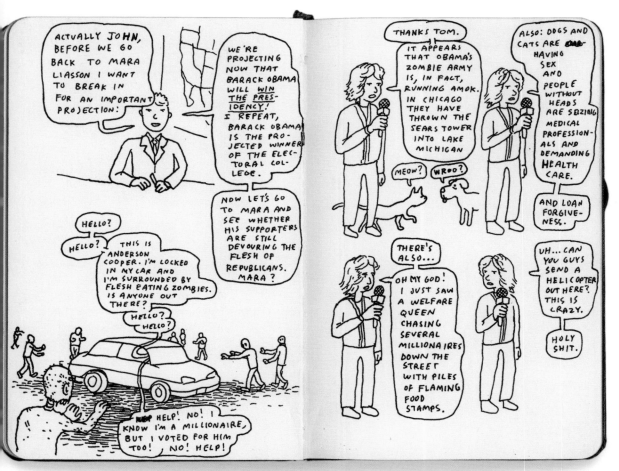

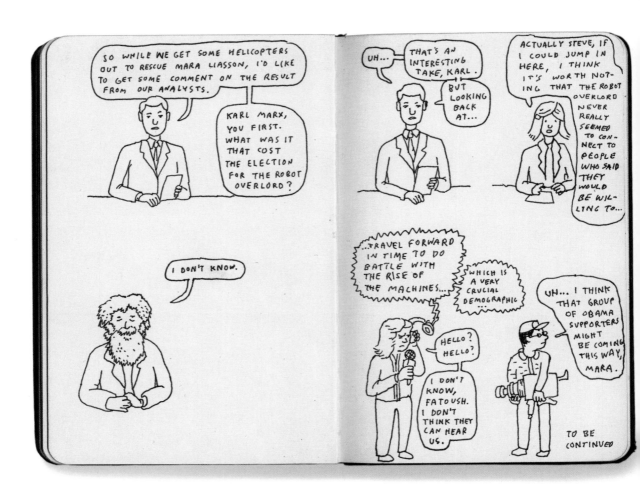

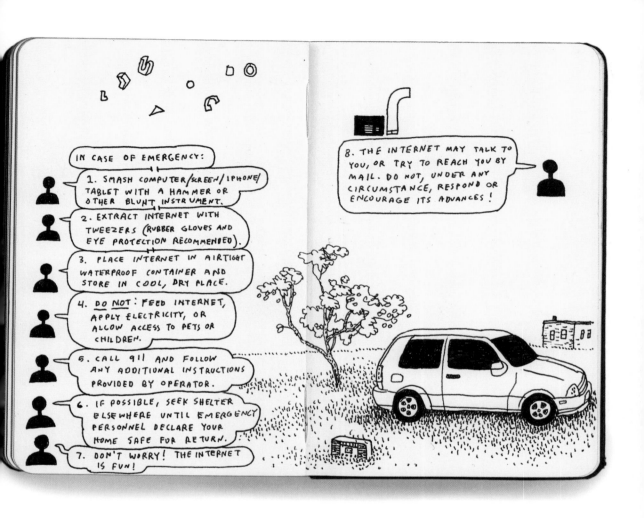

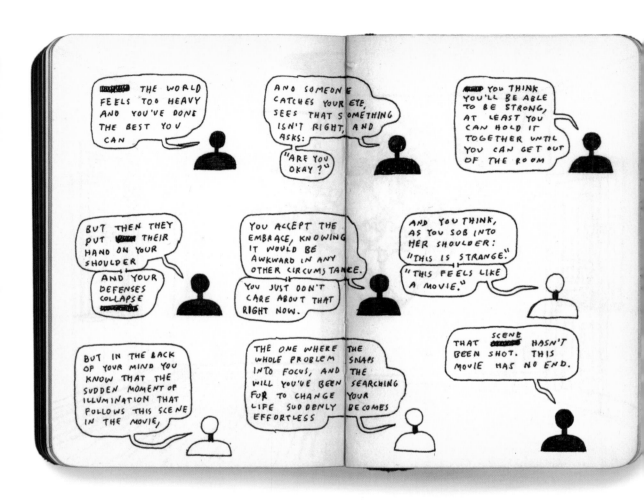

NORAH
JONES

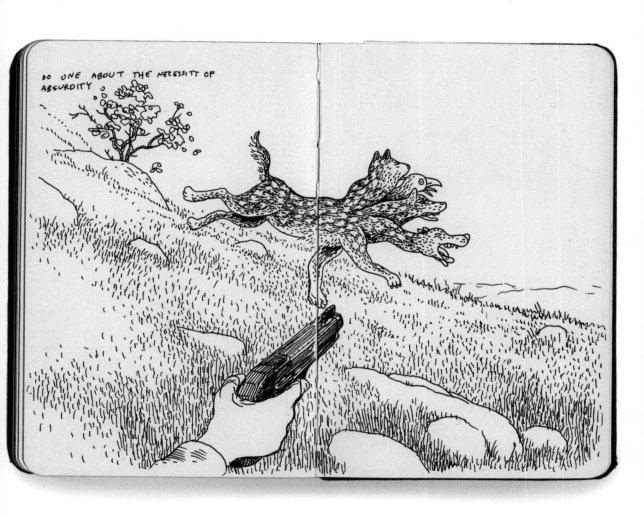

DO ONE ABOUT THE NECESSITT OF
ABSURDITY

CARRIE WASHI-NGTON

HALLE BARRY

ANNE HATHAWAY

RICK CARTER

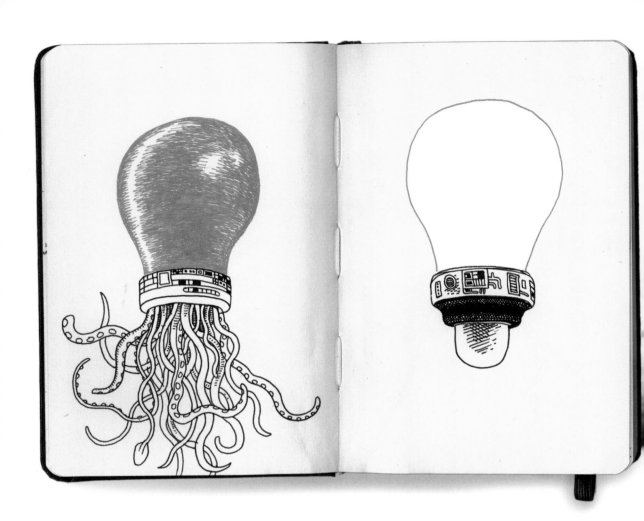

QUVENZHANÉ WALLIS

SHIRLEY BASSEY

ADELE

LIAM NEESON

THE OTHER

I DID A READING FROM ~~I'M NOT~~ DON'T GO WHERE I CAN'T FOLLOW THE OTHER DAY AT BONESHAKER BOOKS IN MINNEAPOLIS. THE BOOK IS A SORT OF MEMORIAL THAT I DID AFTER THE DEATH OF MY PARTNER CHERYL WEAVER IN 2005.

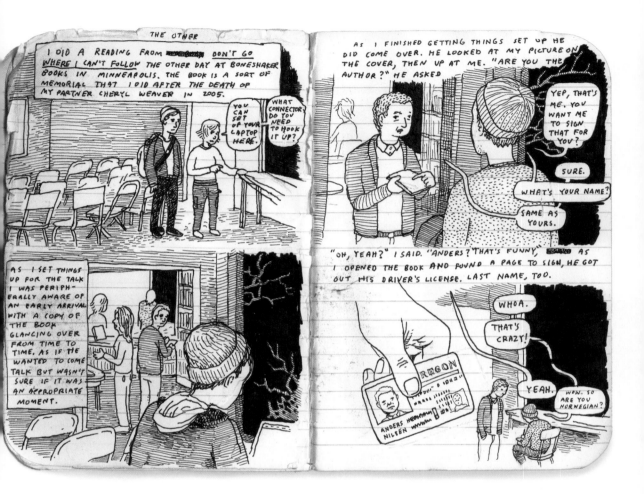

YOU CAN SET UP YOUR LAPTOP HERE.

WHAT CONNECTOR DO YOU NEED TO HOOK IT UP?

AS I SET THINGS UP FOR THE TALK I WAS PERIPH-ERALLY AWARE OF AN EARLY ARRIVAL WITH A COPY OF THE BOOK GLANCING OVER FROM TIME TO TIME. AS IF HE WANTED TO COME TALK BUT WASN'T SURE IF IT WAS AN APPROPRIATE MOMENT.

AS I FINISHED GETTING THINGS SET UP HE DID COME OVER. HE LOOKED AT MY PICTURE ON THE COVER, THEN UP AT ME. "ARE YOU THE AUTHOR?" HE ASKED

YEP, THAT'S ME. YOU WANT ME TO SIGN THAT FOR YOU?

SURE.

WHAT'S YOUR NAME?

SAME AS YOURS.

"OH, YEAH?" I SAID. "ANDERS? THAT'S FUNNY," ~~I SAID~~ AS I OPENED THE BOOK AND FOUND A PAGE TO SIGN, HE GOT OUT HIS DRIVER'S LICENSE. LAST NAME, TOO.

WHOA.

THAT'S CRAZY!

OREGON

ANDERS HERMANN NILSEN

YEAH.

WOW. SO ARE YOU NORWEGIAN?

189

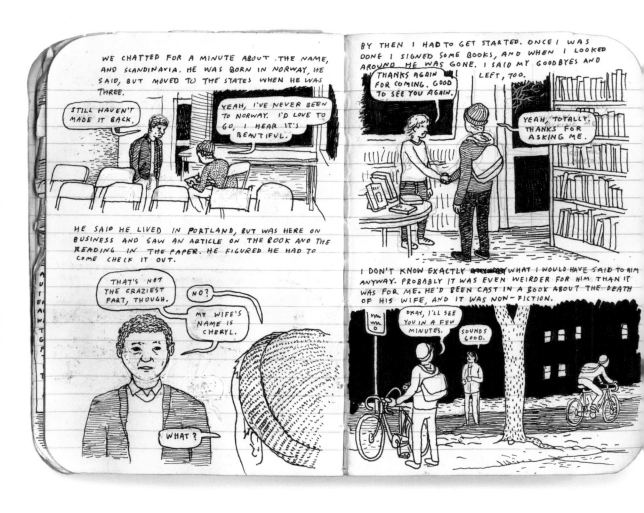

PEOPLE SEE THEMSELVES IN THAT BOOK ANYWAY. I'VE NEVER BEEN COMPLETELY COMFORTABLE ACQUAINTING PEOPLE SO INTIMATELY WITH DEATH. IT'S A BIG RESPONSIBILITY.

I IMAGINE HIM READING IT ON THE PLANE RIDE HOME, FINISHING IT, AND EXPERIENCING THAT WEIRD DISCONNECT OF WATCHING EVERYONE ELSE GOING ABOUT THEIR BUSINESS AS THOUGH NOTHING WAS WRONG.

MAYBE HE'LL JUST DECIDE TO LEAVE THE BOOK ON THE PLANE AND WHEN HIS WIFE ASKS HIM HOW HIS TRIP WAS, HE WON'T MENTION IT.

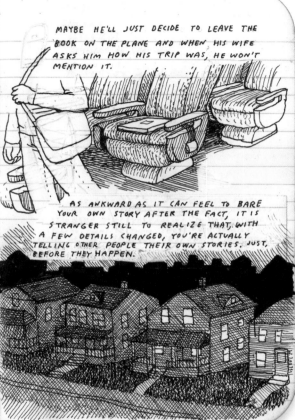

AS AWKWARD AS IT CAN FEEL TO BARE YOUR OWN STORY AFTER THE FACT, IT IS STRANGER STILL TO REALIZE THAT, WITH A FEW DETAILS CHANGED, YOU'RE ACTUALLY TELLING OTHER PEOPLE THEIR OWN STORIES, JUST BEFORE THEY HAPPEN.

I KNOW, RIGHT?

HA HA HA!

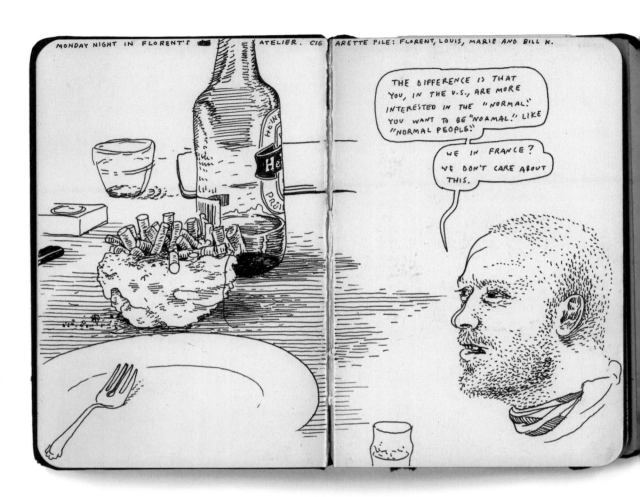

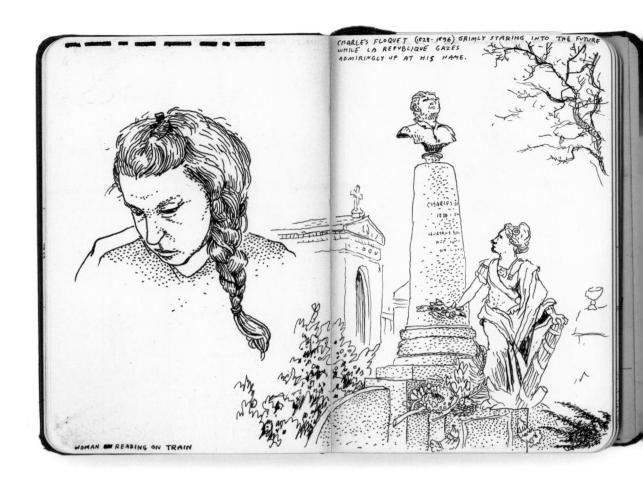

CHARLES FLOQUET (1828-1896) GRIMLY STARING INTO THE FUTURE
WHILE LA REPUBLIQUE GAZES
ADMIRINGLY UP AT HIS NAME.

WOMAN READING ON TRAIN

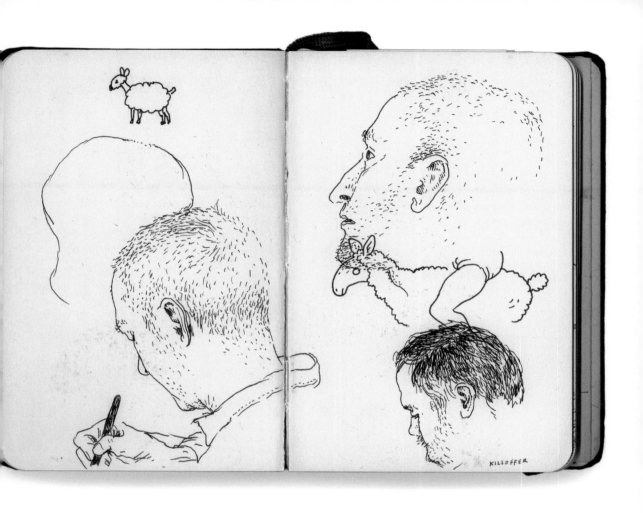

KILLOFFER

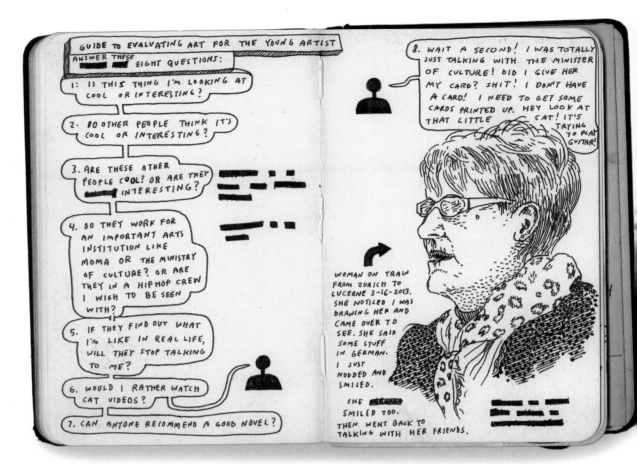

GUIDE TO EVALUATING ART FOR THE YOUNG ARTIST
ANSWER THESE ██████ ██ EIGHT QUESTIONS:

1: IS THIS THING I'M LOOKING AT COOL OR INTERESTING?

2. DO OTHER PEOPLE THINK IT'S COOL OR INTERESTING?

3. ARE THESE OTHER PEOPLE COOL? OR ARE THEY ██████ INTERESTING?

4. DO THEY WORK FOR AN IMPORTANT ARTS INSTITUTION LIKE MOMA OR THE MINISTRY OF CULTURE? OR ARE THEY IN A HIP HOP CREW I WISH TO BE SEEN WITH?

5. IF THEY FIND OUT WHAT I'M LIKE IN REAL LIFE, WILL THEY STOP TALKING TO ME?

6. WOULD I RATHER WATCH CAT VIDEOS?

7. CAN ANYONE RECOMMEND A GOOD NOVEL?

8. WAIT A SECOND! I WAS TOTALLY JUST TALKING WITH THE MINISTER OF CULTURE! DID I GIVE HER MY CARD? SHIT! I DON'T HAVE A CARD! I NEED TO GET SOME CARDS PRINTED UP. HEY LOOK AT THAT LITTLE CAT! IT'S TRYING TO PLAY GUITAR!

WOMAN ON TRAIN FROM ZURICH TO LUCERNE 3-16-2013. SHE NOTICED I WAS DRAWING HER AND CAME OVER TO SEE. SHE SAID SOME STUFF IN GERMAN. I JUST NODDED AND SMILED.

SHE ██████ SMILED TOO. THEN WENT BACK TO TALKING WITH HER FRIENDS.

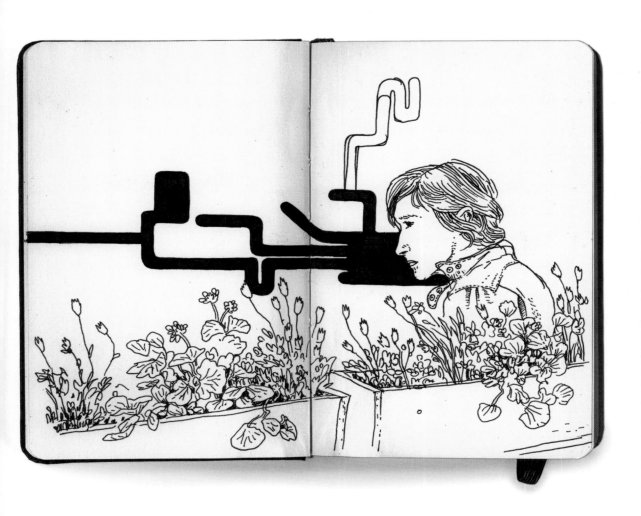

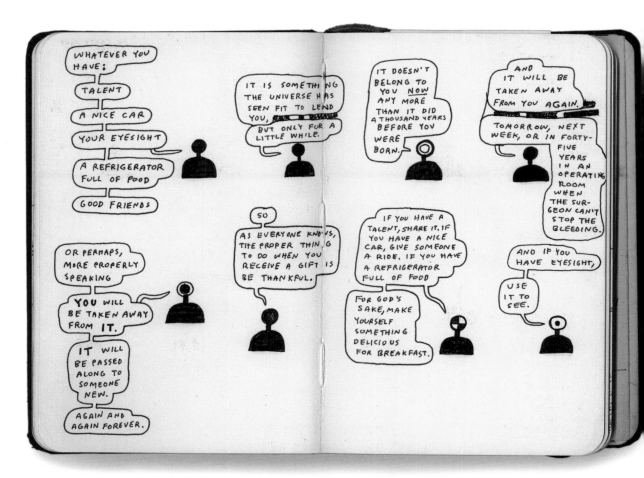

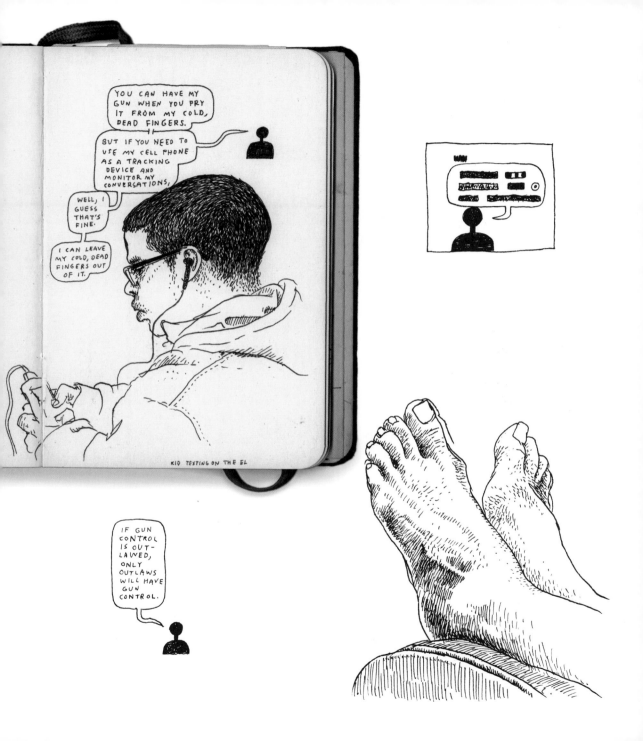

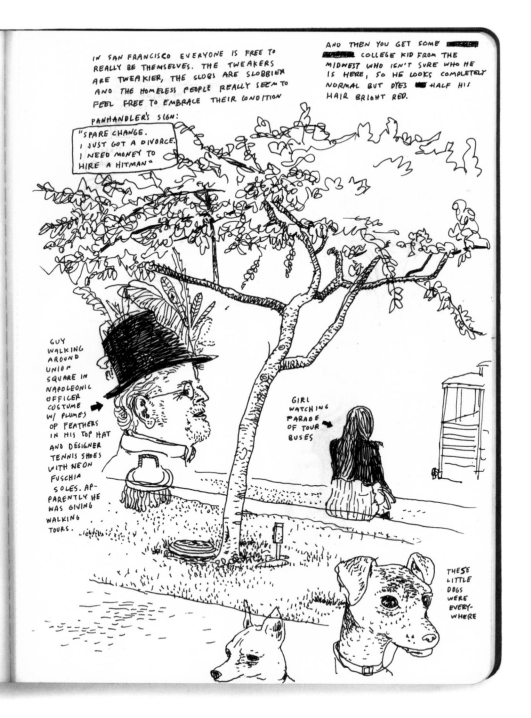

IN SAN FRANCISCO EVERYONE IS FREE TO REALLY BE THEMSELVES. THE TWEAKERS ARE TWEAKIER, THE SLOBS ARE SLOBBIER AND THE HOMELESS PEOPLE REALLY SEEM TO FEEL FREE TO EMBRACE THEIR CONDITION

AND THEN YOU GET SOME ▇▇▇▇ ▇▇▇▇ COLLEGE KID FROM THE MIDWEST WHO ISN'T SURE WHO HE IS HERE, SO HE LOOKS COMPLETELY NORMAL BUT DYES ▇▇ HALF HIS HAIR BRIGHT RED.

PANHANDLER'S SIGN:
"SPARE CHANGE. I JUST GOT A DIVORCE. I NEED MONEY TO HIRE A HITMAN"

GUY WALKING AROUND UNION SQUARE IN NAPOLEONIC OFFICER COSTUME W/ PLUMES OF FEATHERS IN HIS TOP HAT AND DESIGNER TENNIS SHOES WITH NEON FUSCHIA SOLES. APPARENTLY HE WAS GIVING WALKING TOURS.

GIRL WATCHING PARADE OF TOUR BUSES

THESE LITTLE DOGS WERE EVERYWHERE

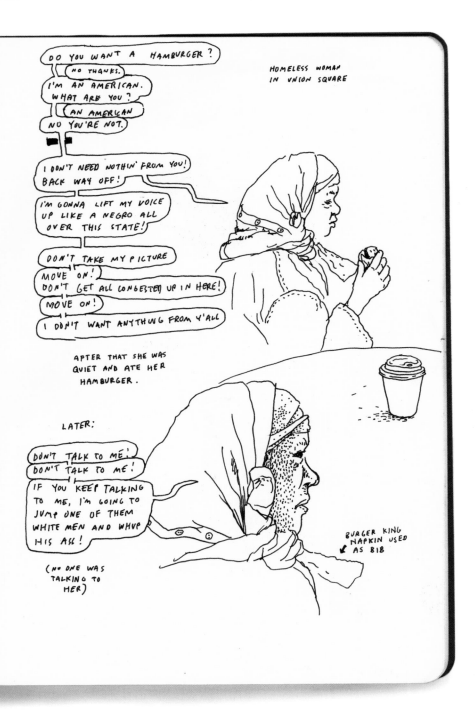

HOMELESS WOMAN
IN UNION SQUARE

DO YOU WANT A HAMBURGER?
NO THANKS.
I'M AN AMERICAN. WHAT ARE YOU?
AN AMERICAN
NO YOU'RE NOT.

I DON'T NEED NOTHIN' FROM YOU! BACK WAY OFF!

I'M GONNA LIFT MY VOICE UP LIKE A NEGRO ALL OVER THIS STATE!

DON'T TAKE MY PICTURE
MOVE ON!
DON'T GET ALL CONGESTED UP IN HERE!
MOVE ON!
I DON'T WANT ANYTHING FROM Y'ALL

AFTER THAT SHE WAS QUIET AND ATE HER HAMBURGER.

LATER:

DON'T TALK TO ME!
DON'T TALK TO ME!
IF YOU KEEP TALKING TO ME, I'M GOING TO JUMP ONE OF THEM WHITE MEN AND WHUP HIS ASS!

(NO ONE WAS TALKING TO HER)

BURGER KING NAPKIN USED AS BIB

201

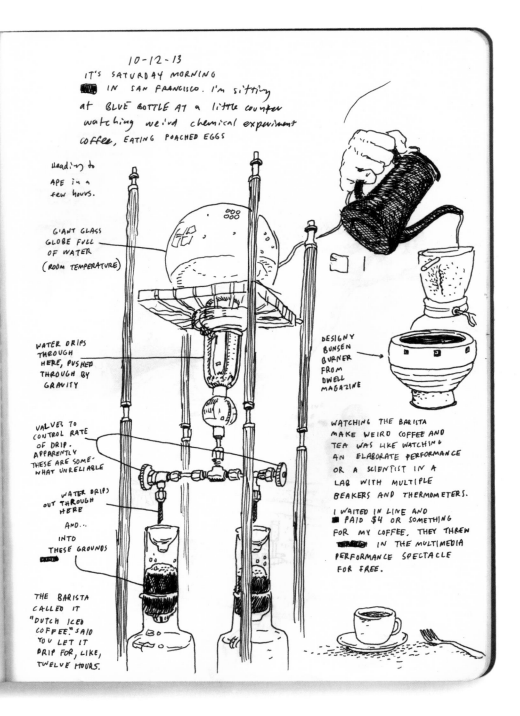

10-12-13
IT'S SATURDAY MORNING
IN SAN FRANCISCO. I'm sitting
at BLUE BOTTLE AT a little counter
watching weird chemical experiment
coffee, EATING POACHED EGGS

Heading to
APE in a
few hours.

GIANT GLASS
GLOBE FULL
OF WATER
(ROOM TEMPERATURE)

WATER DRIPS
THROUGH
HERE, PUSHED
THROUGH BY
GRAVITY

VALVES TO
CONTROL RATE
OF DRIP.
APPARENTLY
THESE ARE SOME-
WHAT UNRELIABLE

WATER DRIPS
OUT THROUGH
HERE
AND...
INTO
THESE GROUNDS

THE BARISTA
CALLED IT
"DUTCH ICED
COFFEE." SAID
YOU LET IT
DRIP FOR, LIKE,
TWELVE HOURS.

DESIGNY
BUNSEN
BURNER
FROM
DWELL
MAGAZINE

WATCHING THE BARISTA
MAKE WEIRD COFFEE AND
TEA WAS LIKE WATCHING
AN ELABORATE PERFORMANCE
OR A SCIENTIST IN A
LAB WITH MULTIPLE
BEAKERS AND THERMOMETERS.

I WAITED IN LINE AND
PAID $4 OR SOMETHING
FOR MY COFFEE, THEY THREW
IN THE MULTIMEDIA
PERFORMANCE SPECTACLE
FOR FREE.

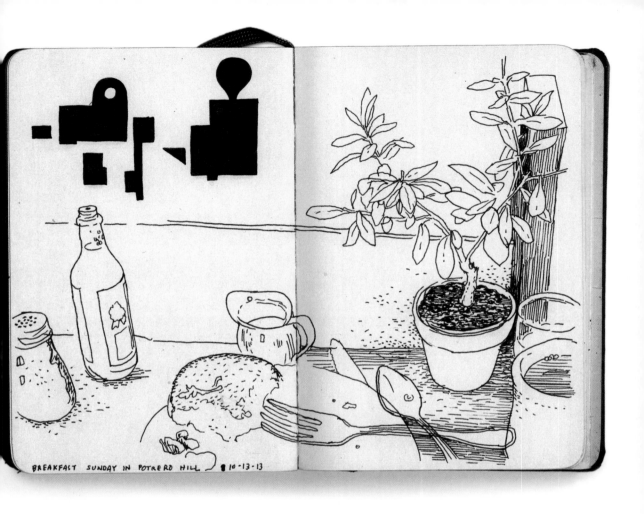

BREAKFAST SUNDAY IN POTRERO HILL 10-13-13

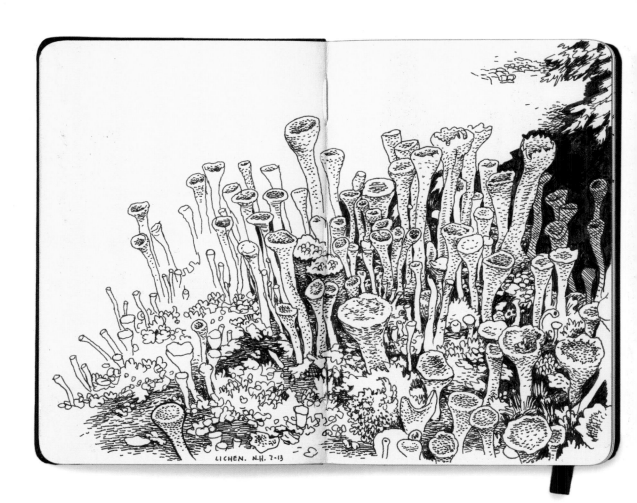

LICHEN. N.H. 7-13

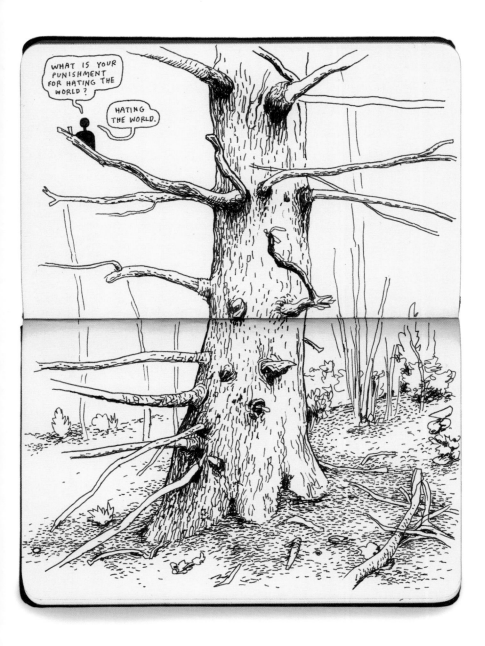

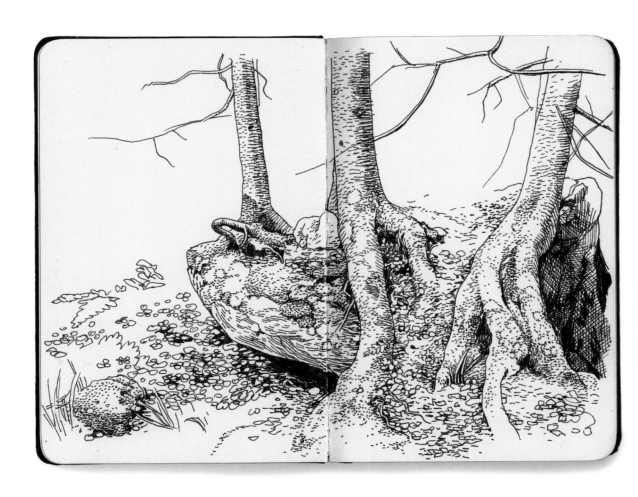

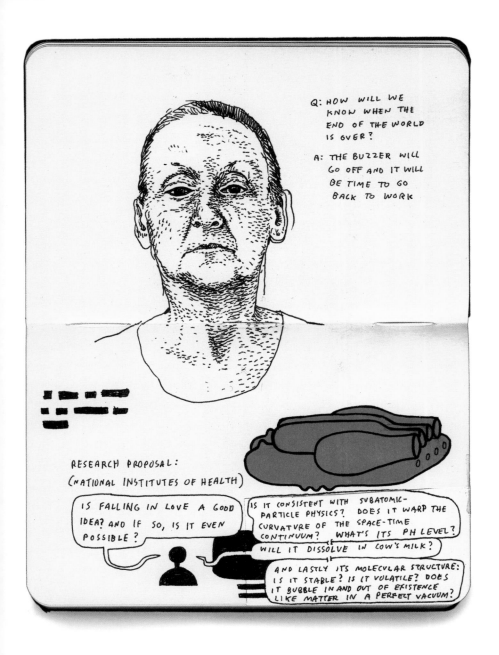

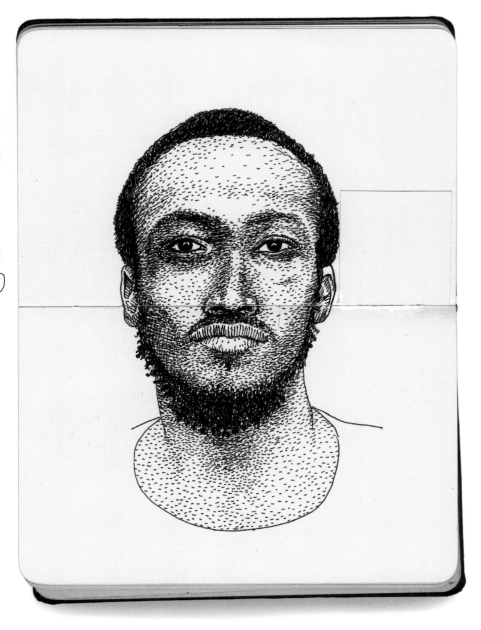

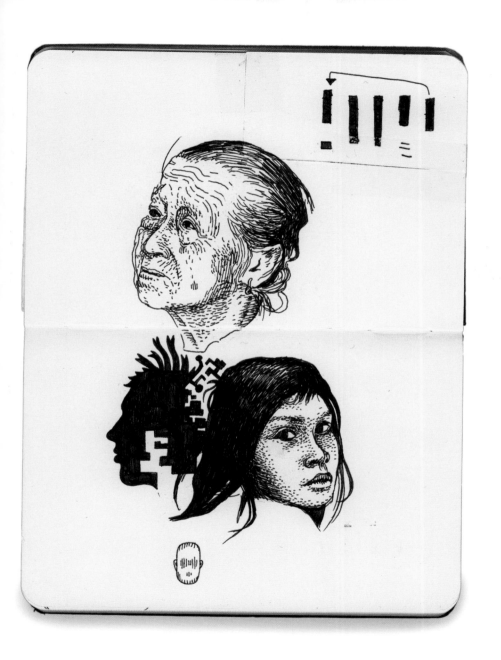

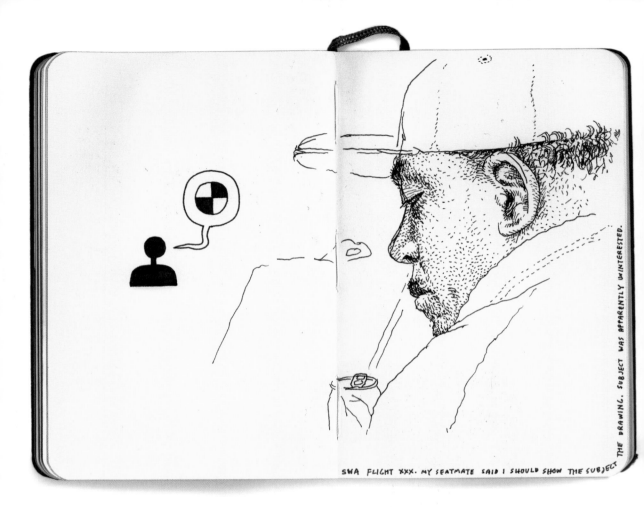

210

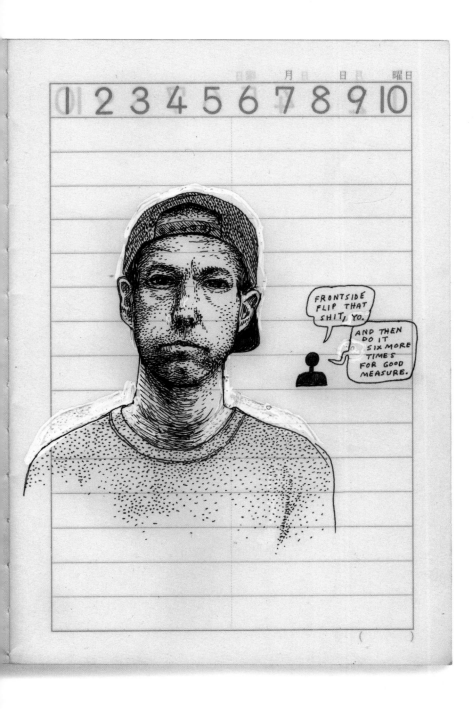

SAMUEL JOHNSON ON
SECOND MARRIAGES:
"THE TRIUMPH OF
HOPE OVER EXPERIENCE."

FAURÉ'S REQUIEM

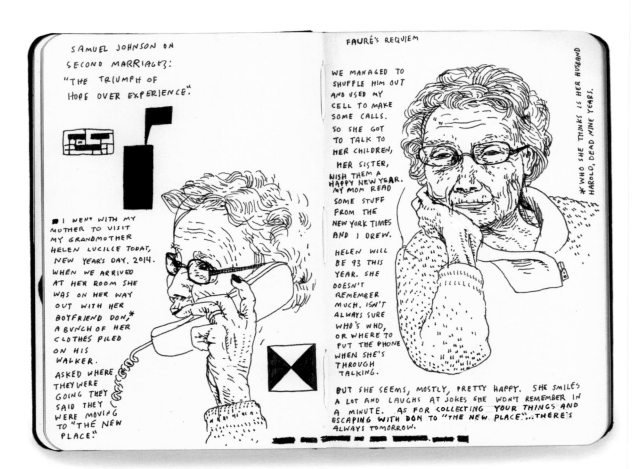

※ I WENT WITH MY
MOTHER TO VISIT
MY GRANDMOTHER
HELEN LUCILLE TODAY,
NEW YEAR'S DAY, 2014.
WHEN WE ARRIVED
AT HER ROOM SHE
WAS ON HER WAY
OUT WITH HER
BOYFRIEND DON,*
A BUNCH OF HER
CLOTHES PILED
ON HIS
WALKER.
ASKED WHERE
THEY WERE
GOING THEY
SAID THEY
WERE MOVING
TO "THE NEW
PLACE."

WE MANAGED TO
SHUFFLE HIM OUT
AND USED MY
CELL TO MAKE
SOME CALLS.
SO SHE GOT
TO TALK TO
HER CHILDREN,
HER SISTER,
WISH THEM A
HAPPY NEW YEAR.
MY MOM READ
SOME STUFF
FROM THE
NEW YORK TIMES
AND I DREW.

HELEN WILL
BE 93 THIS
YEAR. SHE
DOESN'T
REMEMBER
MUCH. ISN'T
ALWAYS SURE
WHO'S WHO,
OR WHERE TO
PUT THE PHONE
WHEN SHE'S
THROUGH
TALKING.

* WHO SHE THINKS IS HER HUSBAND
HAROLD, DEAD NINE YEARS.

BUT SHE SEEMS, MOSTLY, PRETTY HAPPY. SHE SMILES
A LOT AND LAUGHS AT JOKES SHE WON'T REMEMBER IN
A MINUTE. AS FOR COLLECTING YOUR THINGS AND
ESCAPING WITH DON TO "THE NEW PLACE"...THERE'S
ALWAYS TOMORROW.

212

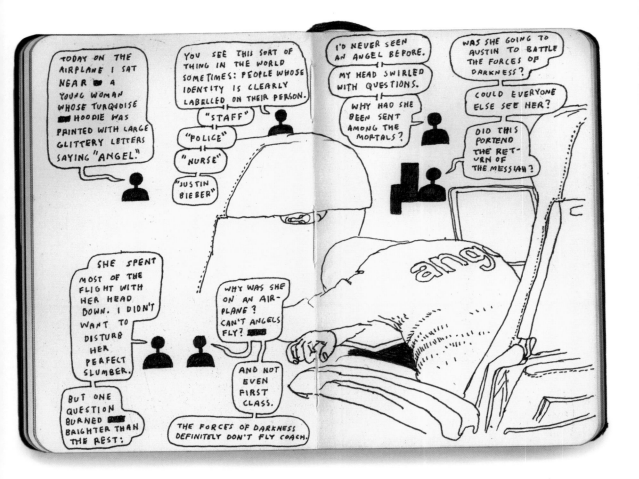

TODAY ON THE AIRPLANE I SAT NEAR A YOUNG WOMAN WHOSE TURQUOISE HOODIE WAS PAINTED WITH LARGE GLITTERY LETTERS SAYING "ANGEL."

YOU SEE THIS SORT OF THING IN THE WORLD SOMETIMES: PEOPLE WHOSE IDENTITY IS CLEARLY LABELLED ON THEIR PERSON.

"STAFF"

"POLICE"

"NURSE"

"JUSTIN BIEBER"

I'D NEVER SEEN AN ANGEL BEFORE.

MY HEAD SWIRLED WITH QUESTIONS.

WHY HAD SHE BEEN SENT AMONG THE MORTALS?

WAS SHE GOING TO AUSTIN TO BATTLE THE FORCES OF DARKNESS?

COULD EVERYONE ELSE SEE HER?

DID THIS PORTEND THE RETURN OF THE MESSIAH?

SHE SPENT MOST OF THE FLIGHT WITH HER HEAD DOWN. I DIDN'T WANT TO DISTURB HER PERFECT SLUMBER.

WHY WAS SHE ON AN AIRPLANE? CAN'T ANGELS FLY?

AND NOT EVEN FIRST CLASS.

BUT ONE QUESTION BURNED BRIGHTER THAN THE REST:

THE FORCES OF DARKNESS DEFINITELY DON'T FLY COACH.

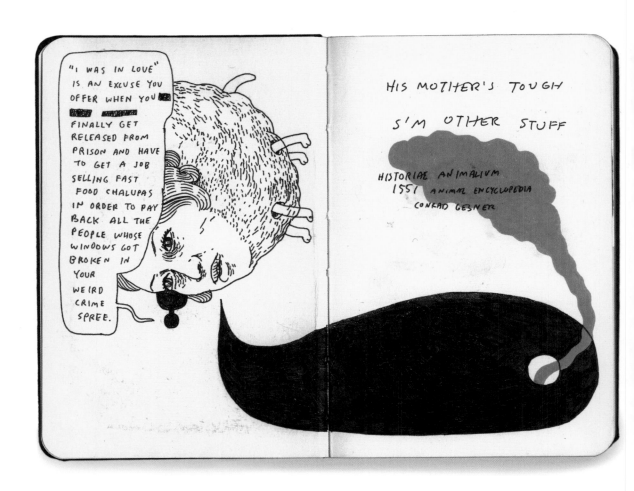

REPORTER: HOW DO YOU
KNOW WHEN
YOU'RE DONE
PAINTING A
PICTURE?

JACKSON
POLLOCK: HOW DO YOU
KNOW WHEN
YOU'RE DONE
MAKING LOVE?

● ● ● ●

AUTHOR'S NOTE: WHAT?

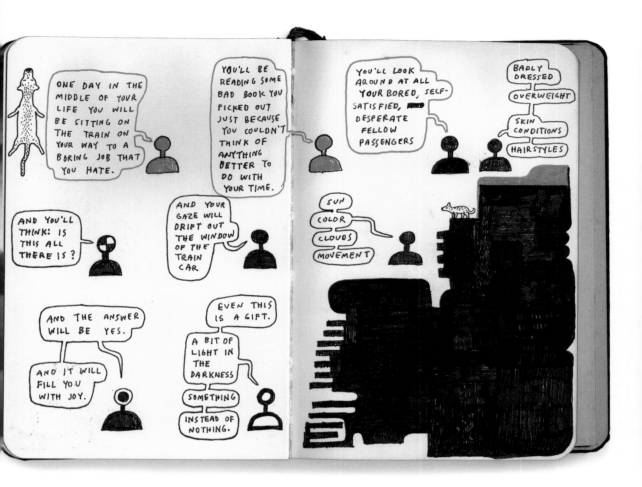

ONE DAY IN THE MIDDLE OF YOUR LIFE YOU WILL BE SITTING ON THE TRAIN ON YOUR WAY TO A BORING JOB THAT YOU HATE.

YOU'LL BE READING SOME BAD BOOK YOU PICKED OUT JUST BECAUSE YOU COULDN'T THINK OF ANYTHING BETTER TO DO WITH YOUR TIME.

YOU'LL LOOK AROUND AT ALL YOUR BORED, SELF-SATISFIED, DESPERATE FELLOW PASSENGERS

BADLY DRESSED
OVERWEIGHT
SKIN CONDITIONS
HAIRSTYLES

AND YOU'LL THINK: IS THIS ALL THERE IS?

AND YOUR GAZE WILL DRIFT OUT THE WINDOW OF THE TRAIN CAR

SUN
COLOR
CLOUDS
MOVEMENT

AND THE ANSWER WILL BE YES.

AND IT WILL FILL YOU WITH JOY.

EVEN THIS IS A GIFT.

A BIT OF LIGHT IN THE DARKNESS

SOMETHING

INSTEAD OF NOTHING.

INKPRESS DUO MATTE 44
50 sheets 13"x19" = $37.00
 ← $74/pm
DUO matte 80 ·
50 sheets 13"x 19" = $42.00

MOAB
entrada rag natural
190# 25 sheets = $65.00

$$\begin{array}{r} 13 \\ 37\overline{)50} \\ \underline{37} \\ 130 \\ \underline{111} \\ 190 \end{array}$$

$$\begin{array}{r} .741 \\ 50\overline{)370} \\ \underline{350} \\ 200 \end{array}$$

$$\begin{array}{r} 2 \\ 74 \\ \underline{5} \\ 3.70 \end{array}$$

5.00 paper
17 ink cartridge

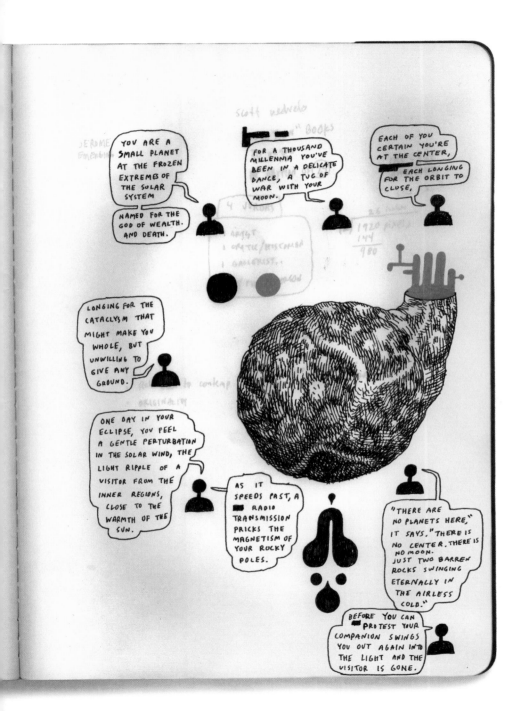

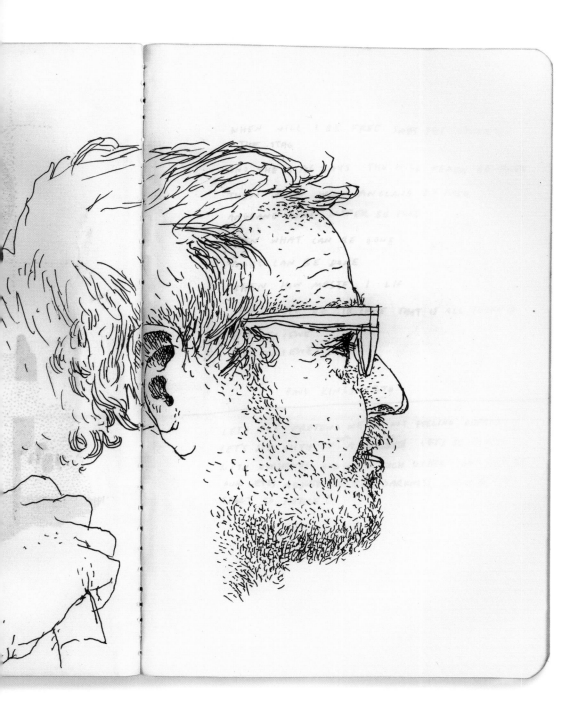

TELLING YOUR STORY

LIFE DOESN'T FIT ~~INTO~~ NEATLY
INTO A NICE HOLLYWOOD
STORY ARC.

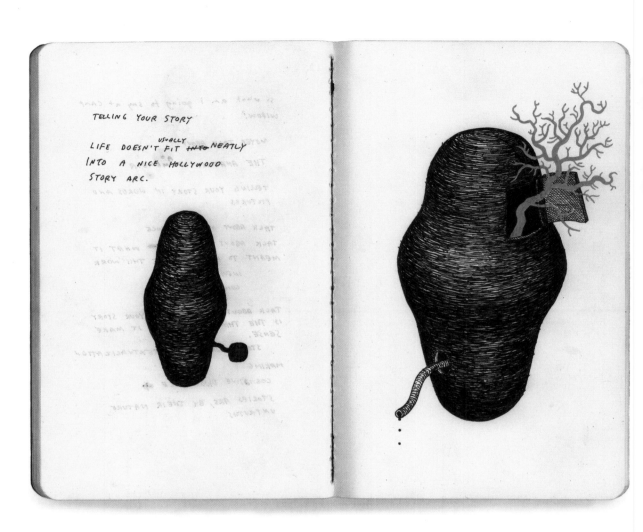

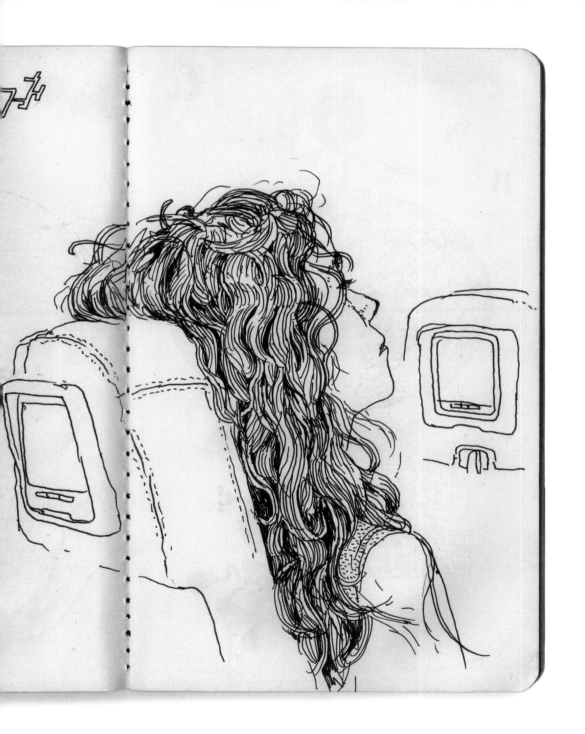

index

INDEX STATISTICAL ANALYSIS

Most Cited Subjects

God	23
truisms	12
love	11
the weather	11
drawings of people in audiences	9
drawings of people in cars	8
philosophical frameworks	8
poetry	8
the end of the world	7
traffic accidents	7

Most Cited Pages

128	10
22	8
84	8
8	7
34	6
97	6
184	6

Most of the preceding material originally appeared online at themonologuist.blogspot.com. Some of it has also previously appeared in print in supplemental minis; the anthologies *Mome*, *Smoke Signal*, *Bateau*, and *Forresten*; the magazine *bomb*; and the book *Drawn In* (edited by Julia Rothman). The collage pieces on pages 59–65 were originally done for a couple of annual Post-It shows put together by Esther Pearl Watson and Mark Todd at Giant Robot.

Thanks to Esther and Mark, Gabriel Fowler, Sara Drake, Alexandra Zsigmond, and Tracy Hurren, and for production assistance to Marie-Jade Menni, Max Queripel, Spencer Amundsen, Connor Rice, Jei Gross, and Mandie Brasington.

drawnandquarterly.com

First hardcover edition: July 2015. Printed in China. 10 9 8 7 6 5 4 3 2 1

Library and Archives Canada Cataloguing in Publication: Nilsen, Anders, 1973–, author, illustrator. *Poetry is Useless*/Anders Nilsen. isbn 978-1-77046-207-6 (bound) 1. Nilsen, Anders, 1973– —Travel—Comic books, strips, etc. 2. Graphic novels. I. Title. pn6727.n56z46 2015 741.5'973 c2014-907023-3

Published in the usa by Drawn & Quarterly, a client publisher of Farrar, Straus and Giroux. Orders: 888.330.8477.
Published in Canada by Drawn & Quarterly, a client publisher of Raincoast Books. Orders: 800.663.5714.
Published in the uk by Drawn & Quarterly, a client publisher of Publishers Group uk. Orders: info@pguk.co.uk.